IMAGES
of America

HASBROUCK HEIGHTS

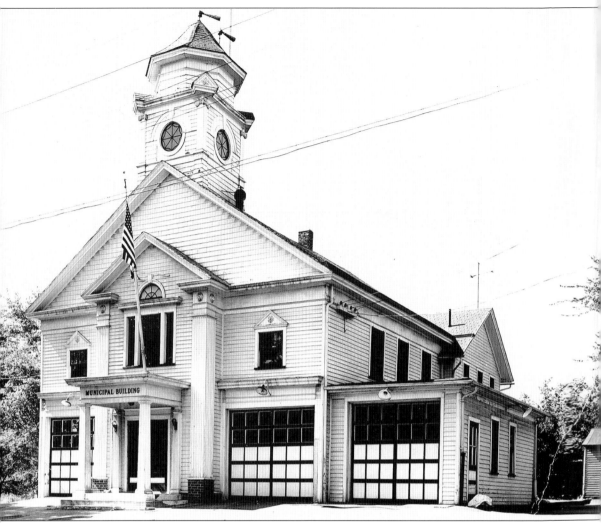

This Hasbrouck Heights Municipal Building was built in three stages. Pictured around 1940, it grew to house many of the borough departments. In the early 1950s, the newly enlarged building was opened. Unfortunately, in December 1999, the building burned down. The new municipal building now stands on the Boulevard (between Central and Madison Avenues) and the police and fire department's new headquarters now stands on Hamilton Avenue.

On the cover: A member of the Hasbrouck Heights Fire Department gets ready to respond to a fire call around 1917. (Courtesy of the Heritage Room at the Hasbrouck Heights Library.)

IMAGES
of America

HASBROUCK HEIGHTS

Catherine Cassidy
for the Friends of the Hasbrouck Heights Library

ARCADIA

Published by Arcadia Publishing
Charleston SC, Chicago IL, Portsmouth NH, San Francisco CA

Printed in the United States of America

Library of Congress Catalog Card Number: 2005936975

For all general information contact Arcadia Publishing at:
Telephone 843-853-2070
Fax 843-853-0044
E-mail sales@arcadiapublishing.com
For customer service and orders:
Toll-Free 1-888-313-2665

Visit us on the internet at http://www.arcadiapublishing.com

This early-20th-century postcard sends "Greetings from Hasbrouck Heights."

CONTENTS

ACKNOWLEDGMENTS

This book would not have been possible without the cooperation of library director Michele Reutty, the Hasbrouck Heights Free Public Library Board of Trustees, and the Friends of the Library. The suggestion for writing this book came in part from Joseph Luongo, the superintendent of schools. After I coauthored the Arcadia book on Wood-Ridge, he suggested I write one on Hasbrouck Heights. I thought about it for a while and decided to do it. I spoke with Borough Historian Louise Davenport, who also thought it was a good idea. Her assistance and guidance throughout this process have been invaluable.

I would also like to thank all the people who helped in the creation of this book: Carolyn Cassidy; Elizabeth McGinty; Donna Mikulka; Barbara Kiefer Smith; Alice Davenport; Doris Meyer; Erin Schneeweiss; Kathleen Hieswa; Elsie Ardito Sternbach; Laura Howe Czekaj; the Condal and McCrystal families; Thomas and Carol Macher Mason Sr.; Phyllis Irwin Fass; Kevin Wright, president of the Bergen County Historical Society; Nick Delcalzo; Lt. Shawn Mullins of the Hasbrouck Heights Police Department; Hasbrouck Heights Borough Administrator Michael Kronyak; and Hasbrouck Heights Borough Clerk Rose Marie Sees. I would also like to thank my professors at Montclair State University, Dr. Leslie Wilson and the late Dr. Joel Schwartz. I would like to thank my 2005–2006 Advance Placement History Class and the road trip crew for listening to me talk about the book. If I inadvertently omitted someone, I apologize.

Material for this book comes from Michele Reutty's in-depth centennial history book, which she authored in 1994, William Oelker's 50th anniversary book printed in 1944, and the 1964 70th anniversary booklet. As cited here, I did not footnote this book. The research and time, which Reutty, Oelkers, and the Junior Woman's Club devoted to these publications, is unsurpassed. These three authors' hard work has made this an interesting project for me. The information used for this work is as accurate as possible. When researching, information is sometimes conflicting, and I apologize for any inaccuracies that may be found. All photographs, unless otherwise noted, are from the files in the Heritage Room of the Hasbrouck Heights Library. Undoubtedly, more information and photographs will come to me after the printing of this book. I tried to use photographs that not only show the subject, but also the background. I hope you find this book enjoyable. All proceeds benefit the Friends of the Hasbrouck Heights Library.

INTRODUCTION

Although August 12, 1894, is the date on which Hasbrouck Heights was incorporated, the borough's history goes back to the late 1600s when Capt. John Berry purchased over 11,000 acres of land from Lord Carteret. Hasbrouck Heights, along with the neighboring communities, was part of this land purchase.

The Dutch played a huge part in the formation of early Bergen County. The families were named Terhune, Ackerman, Vreeland, and Van Bussum, among others. If one looks back to early records, these are the names which pop up often during this time throughout Bergen County.

One of the first public roads between Hackensack and Rutherford was Polifly Road, which was built in 1707. In fact, during its early history Hasbrouck Heights was known as Polifly from the Dutch word *Pole-Vly*, which means top of the meadow.

Hasbrouck Heights, or Polifly at the time, played an important part in the formation of our nation. Gen. George Washington and his troops marched through Hasbrouck Heights while retreating from New York during the Revolutionary War in 1776. Retreating along this road allowed the Continental Army to safely escape from the British. Washington used this route again in 1783 on his way from Newburgh, New York, to Princeton, New Jersey.

Unfortunately, only one of the Old Dutch stone homes still exists somewhat intact. Sylvester's Restaurant, which is a remodeled Dutch home, has been a restaurant for decades. It is the oldest existing building in Hasbrouck Heights. The last Dutch home, which was owned by John Meyers, was torn down to make way for Route 46 (then known as Route 6). Some of the stones were reused in homes being constructed on Cleveland and Harrison Avenues. It was at John Meyers's residence that George Washington allegedly stopped.

With the war won and our nation on the road to greatness, farms became more abundant. With the invention of the steam engine, railroads were able to transport people from urban centers to the suburban farm communities. In the 1870s, developers became interested in Hasbrouck Heights. One of the more influential was the Center Corona Land and Building Association. Numerous farms were purchased. Hasbrouck Heights at this time was known as Corona and was part of Lodi Township. In 1871, another developing corporation, the South Corona Land Association, purchased acreage between Hamilton and Franklin Avenues. This was the start of something big.

One

Early Hasbrouck Heights

In the mid-1800s, although primarily farms, the town was on the threshold of becoming a bustling community. The railroad assisted greatly in this endeavor, as did two gentlemen.

Daniel Morse and Henry Lemmermann created the residential community known today. Morse owned the area from Walter Avenue north to Kipp Avenue. Lemmermann owned the property from Kipp Avenue to LaSalle Avenue. Lemmermann's company built homes, provided streetlights and general improvements, and financed civic groups. They became the most influential men in town. At auctions of the parcels, an average lot in their development sold for $147. Sometimes two-year free commuter tickets to New York were given to the purchasers. Edward Anson, who later became the postmaster in Hasbrouck Heights, also built approximately 100 homes.

Exactly how Hasbrouck Heights was named has been disputed. Because of confusion with Corona, New York, the federal government was petitioned to change the name to Hasbrouck after resident Jacob Hasbrouck. But there was a Hasbrouck, New York, so the word Heights was added, immortalizing Jacob Hasbrouck for years to come. Hasbrouck had been a general manager for the New York and New Jersey Railroad. When the town officially became known as Hasbrouck Heights on January 1, 1890, formation of a borough government was discussed.

A committee was created by the Corona Improvement Association to look into forming a government, but since large landowners objected, the boundaries of the young town were small. As 1894 approached, borough fever swept the area. The New Jersey legislature enacted the Borough Act, making each township a separate district. Many Bergen County towns were formed at this time, including Hasbrouck Heights, but only after a very close and bitter vote. The borough was finally incorporated on August 12, 1894.

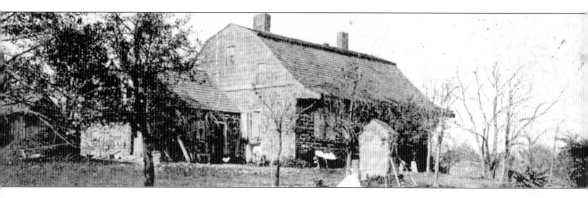

The Ackerman and Brinker Home, one of the Old Dutch farmhouses located in Hasbrouck Heights, was built in 1728. The home was located on Terrace Avenue between Columbus and Cleveland Avenues.

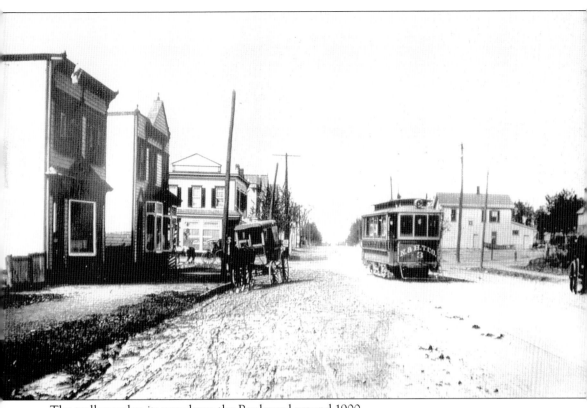

The trolley makes its way down the Boulevard around 1900.

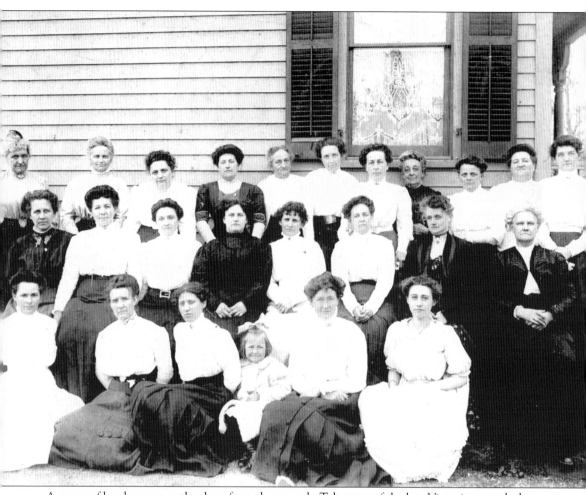

A group of local women gather here for a photograph. Take note of the late Victorian-era clothes; it is around 1890.

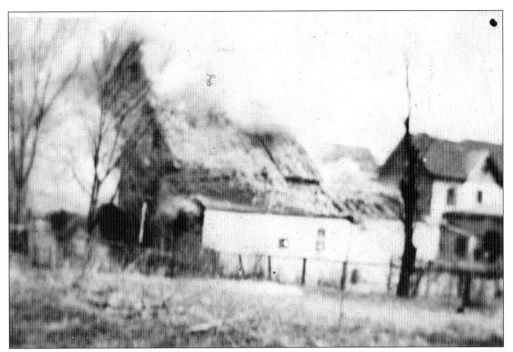

Pictured here is the Van Bussum family barn. The Van Bussum home still stands on Terrace Avenue.

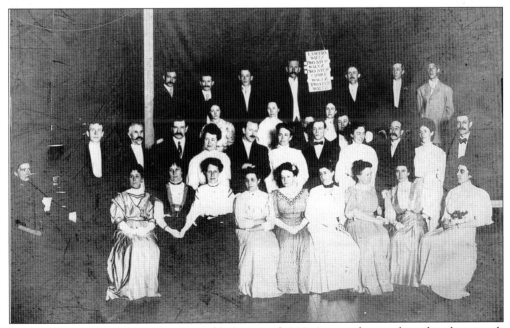

Shown is the Hasbrouck Heights Assembly Season of 1908. Among the people in this photograph are (seated, first row) Mrs. Scarr, unidentified, unidentified, May Kelly, Emily Herold Humbert, unidentified, unidentified, Mrs. Webb, and Mrs. Powelson; (second row) Mrs. Peters (at the piano), unidentified, unidentified, Mrs. Kerwin, Mr. Kerwin, Miss Quigg, John Southwick, unidentified, Mr. Beals, and Mrs. Beals. The remaining members are unidentified.

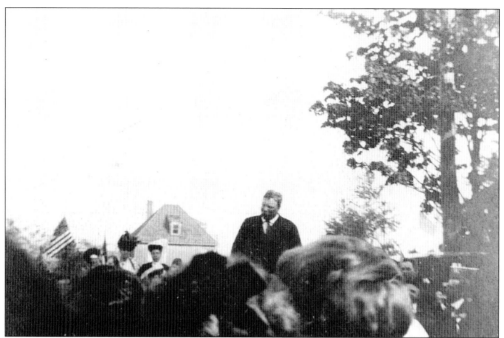

Pres. Theodore Roosevelt makes a speech while campaigning in Hasbrouck Heights. The photograph was most likely taken in the area of Franklin and Terrace Avenues. The date on the photograph states 1908. Roosevelt ran for president in 1904 as a Republican and as the Bull Moose candidate in 1912. The photograph could also possibly date from his run for vice president in 1900.

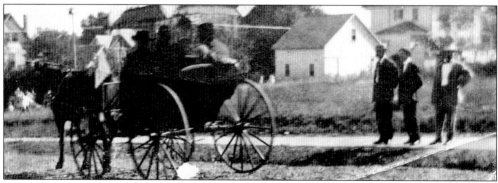

Mayor Austin enjoys a ride in a buggy around 1910.

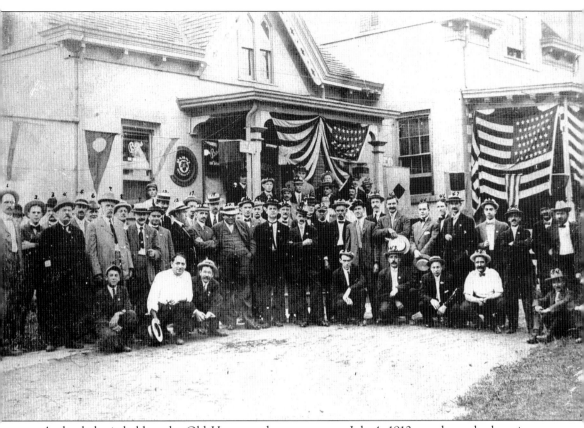

A clambake is held at the Old Homestead restaurant on July 4, 1912—perhaps the last time the local Democratic and Republican parties gathered together. Among the men who have been identified are Gus Siebermann, Morris Southwick, Frank Lorenz, George Blaney, Leo Abt, J. G. Martin, George Ellwood, William Oelkers, John Musselmann, Percy Hester, Arthur Ohmes, James Harvard, David Abt, Frank Cranwell, Ed Little, Joe Metz, G. Austin, Charles Weiner, Pop Hester, William Porter, Al Mitchell, B. F. Cleveland, H. Chapman, John Scheuerer, J. Vanier, J. Zimmermann, Harry Brooks, Earl Hester, George Ramsden, Charles Feury, P. Adrain, G. Metz, Pop Lawrence, Bill Keogh, George Smith, Lester Thurston, John Bulmer, Hans Neumann, John Glassrunner, Pat McHugh, T. Halcy, Harry Brigham, Miles Madison, Count von Eggloftstein, Tony Moran, Mr. Hunt, Neil Murphy, Henry Gross, Tony Milani, Bill King, and Fred Depken.

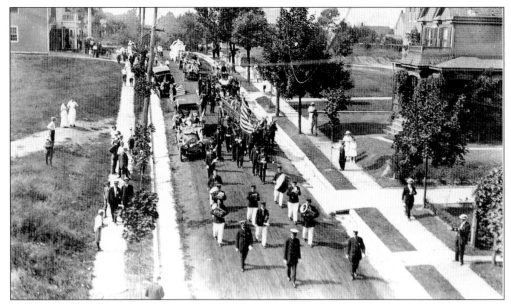

The 1915 Labor Day Parade begins at the Hasbrouck Heights Municipal Building on Hamilton Avenue.

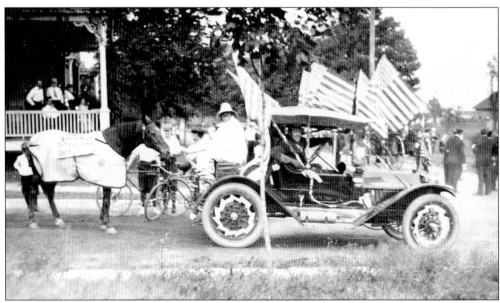

A parade is held on Terrace Avenue, possibly near Jefferson Avenue, around 1915. The sign on the horse reads, "I may have to pull that yet!"—meaning the automobile is not quite as reliable as one might think.

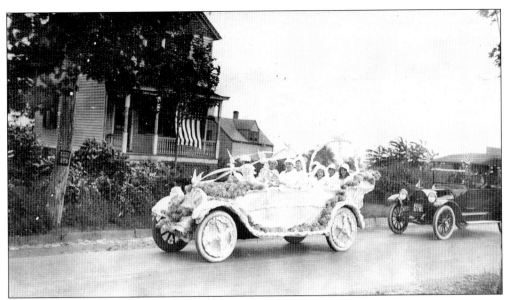

This is the "Best Decorated" car in the 1915 Labor Day Parade.

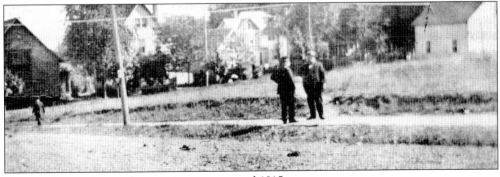

Two gentlemen discuss the town's events around 1915.

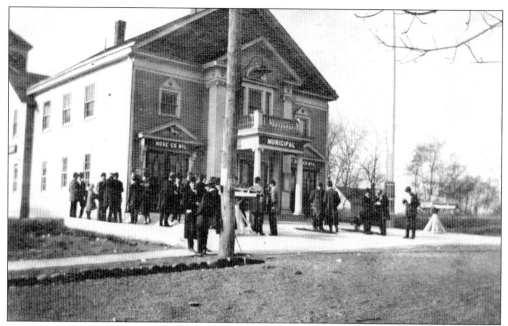

Residents leave a celebration at the Hasbrouck Heights Municipal Building around 1918. Note the guns flanking the building.

Shown around 1900 is one of the many beautiful Victorian-style homes in the area. This one is on Springfield Avenue.

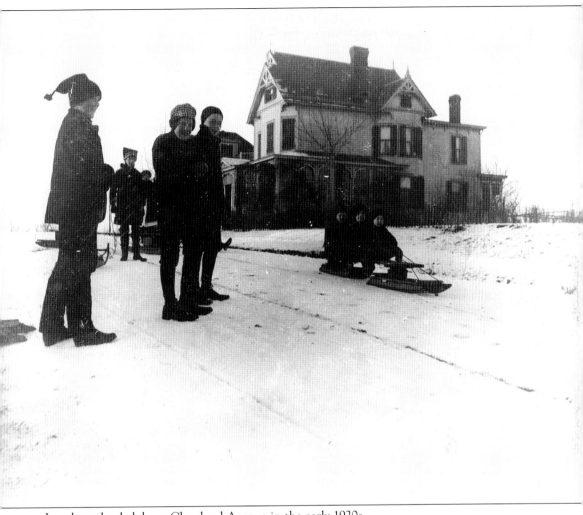

Local youths sled down Cleveland Avenue in the early 1920s.

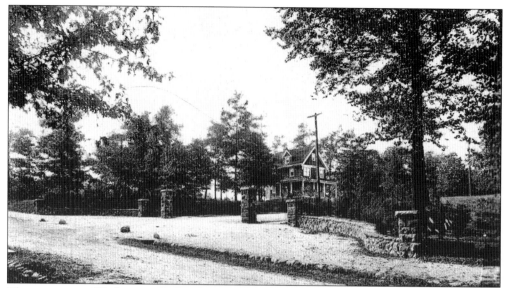

The entrance to Washington Park is located at the end of Washington Place and Oak Grove. It is pictured here around 1914.

Pictured around 1910, these homes still stand on Terrace Avenue, between Raymond Street and Division Avenue.

Surreal now, this bucolic scene of the "skinny" cow, owned by the Hiatt family, was taken in 1920, near the athletic field.

This *c.* 1920 photograph shows Washington Place east of the Boulevard.

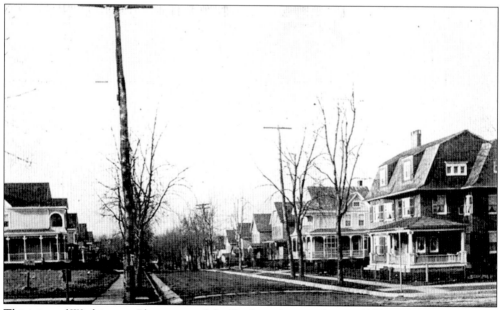

This view of Washington Place, west of the Boulevard, was taken in 1920.

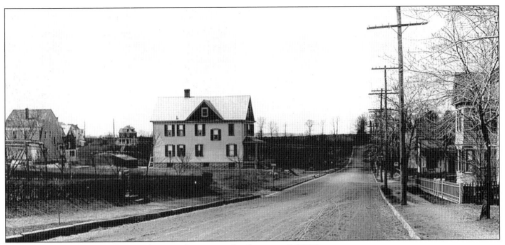

A street in Hasbrouck Heights is photographed around 1915.

Central Avenue, west of the Boulevard, is shown around 1920.

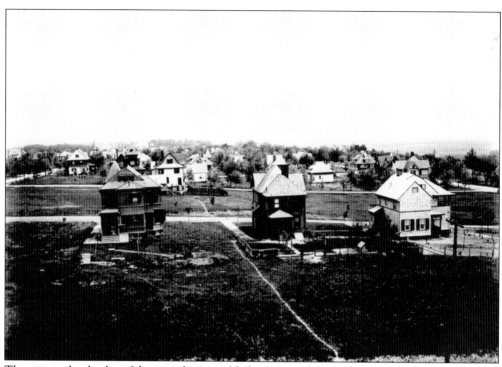

These are the backs of homes that are likely facing Henry Street, near Burton Avenue, around 1915.

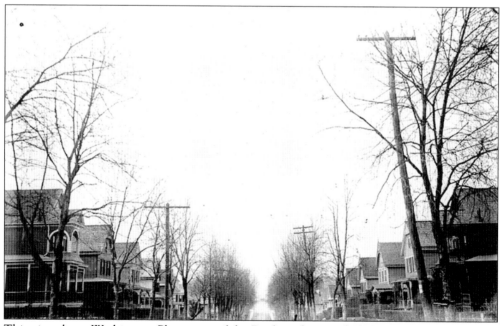

This view shows Washington Place, west of the Boulevard, around 1920.

Two

THE POLICE AND FIRE DEPARTMENTS

One police officer, better known as a constable, patrolled the town between 1886 and 1909. The constable had marshals to help if needed. In May 1909, a police department was established consisting of two commissioners who were members of the Borough Council and three patrolmen. In subsequent years the department expanded rapidly. The weekly patrolman's salary at this time averaged $6 per week. The first chief of police was Eugene Roeser. He had previously served as a marshal, but at this time police duties were carried out only in the daytime. Unfortunately, Roeser died in an automobile accident in 1919. In 1930, the department was increased to nine men, in order to better handle the growing population and increasing traffic. New patrol cars were added in the 1930s after Officer Gerald Delamater was killed while riding a police motorcycle. Motorcycles were banned from this point on. The 1930s also saw radios installed at Borough Hall and in the police cruisers. Two more patrolmen were added in the 1940s, with an additional five in the 1950s. In the 1970s, the ranks rose, and today the department stands at 32. The department is ever vigil in its fight against crime and its diligence in arresting drunk drivers. As the electronic sign says, "You drink, you drive, you lose."

A series of fires occurred in the borough in 1894. The insurance companies said they were going to cancel the town's policies if a fire department was not started; so in 1894, the Hasbrouck Heights Fire Department was formed. At first there were two types of members: social members, who paid dues, and active members, who paid dues and fought the fires. The dues were approximately $2.50 a year. The early fire department did not fall under the borough government, but under the Board of Fire Commissioners. Two companies were formed: Hook and Ladder and Bucket Company No. 1 and Hose Company No. 1. The first truck was hand-drawn and had a ladder and bucket that cost $265. It remained in service until the department began using automobiles in 1917.

As there was no place available to store the equipment, the department purchased land on Hamilton Avenue. The first floor housed the department's equipment, and the second floor had a meeting room where the mayor and council and fire department held their meetings. With interest from volunteers declining, the fire department negotiated with the mayor and council to take over control in 1896. The first fire department chief under borough control was John Graves, who served until 1899. The department purchased two Ford Model T trucks. During the

ensuing decades, the department expanded with the times, and in 1949, it signed a contract with the Borough of Teterboro to respond to fires and emergencies in the town. This agreement is still in effect. The first fire whistle was installed in 1913 and the first alarm boxes in 1915.

The Hasbrouck Heights Ambulance Squad was established in 1941 and included the firefighters. Today, the ambulance squad utilizes two rigs answering over 1,000 calls a year. The evolution of this 50-member volunteer staff has made it the premier department it is today, celebrating 110 years of public service.

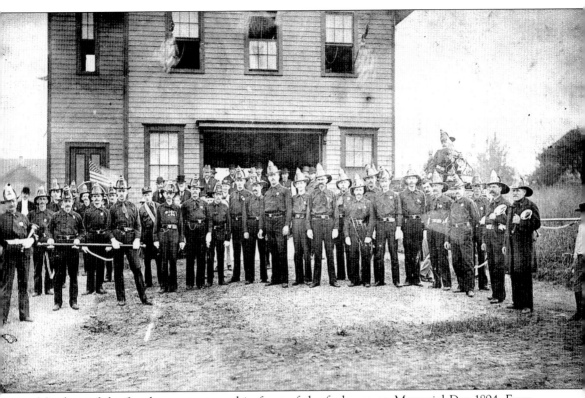

Members of the fire department stand in front of the firehouse on Memorial Day 1894. From left to right are (first row) holding the rod Gus Sieberman and unknown, Ed Wilhelm, Ed West, Charles Robbins, Mr. Fox, Jason Bell, Alfred Chastney, Charles Amsler, Mr. Cleveland, Joseph Porter, Charles Freeman, Frank Flagg, Garrett Bush, Mr. Thys, James Chastney, K. Powell, J. Ramsden, John Graves, and Mr. Costigan; (second row) John Alcorn, Dr. Shepphard, Mr. Selig, Mr. Van Bussum, Mr. Musselmann, and Mr. Norsk. Robert Wilhelm and Clifford Smith are on the truck and to the extreme right of the photograph is Fred Martin.

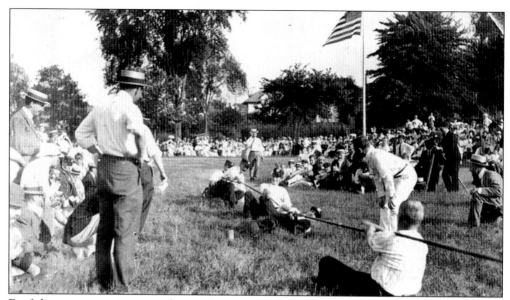

Firefighters compete in a tug-of-war at Lemmermann Park around 1915. Note the man filming the event, to the right of the man bending over.

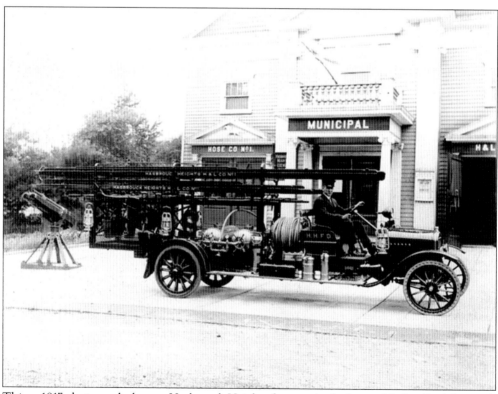

This c. 1917 photograph shows a Hasbrouck Heights fireman in the borough's first Ford fire truck in front of the old municipal building and fire department.

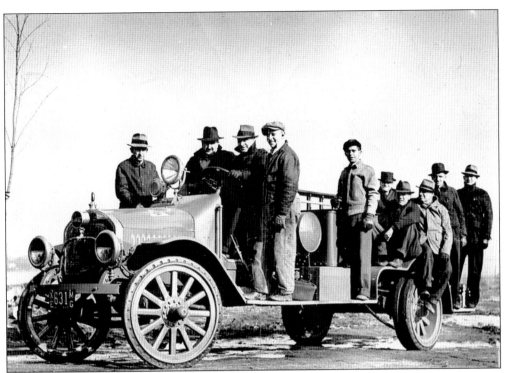

Firefighters test an antique piece of equipment in 1942. Observe the partially blacked out headlights because of the war.

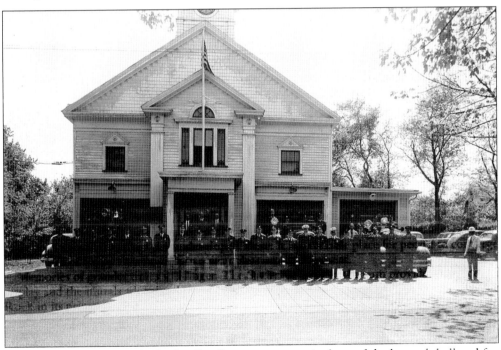

Members of the Hasbrouck Heights Fire Department pose in front of the borough hall and fire department around 1945.

How The Municipal Building Was Built

Built in four stages, the new Municipal Building of the Borough of Hasbrouck Heights is now completed. It is located at 248 Hamilton Avenue and replaces a wooden structure erected in the 1890's which was found inadequate and in dangerous condition.

The new building was begun in 1950 with construction of the east wing. Land had to be purchased to the east to provide for this wing and a convenient parking area. In the east wing are housed the Fire Department hook and ladder, one pumper and the emergency light truck. On the first floor there is an office for the Fire Chief and a room for storage of Fire Department equipment. On the second floor one finds the handsome quarters of the firemen in which they rest. The room was finished by the volunteers at their own expense. It has a small kitchen often in use. Two lavatories are off the corridor of this wing.

Next came the west wing in 1952. In this is the Police Department with modern law enforcement equipment. The clerk is of steel with two-way radio and fire alarm controls. There is an office for the Chief and a record bureau and detective office combined. There are two approved cells and a lavatory. In front of this wing are garaged another Fire Department pumper and the ambulance. On the second floor of the west wing are the offices of the Borough Clerk, a conference room, a small clerk room and the Community Room which is used by more than twenty local organizations.

In the basement of this wing are a police squad room, three lavatories, space for a future indoor pistol range, two vaults and two custodian's closets.

The third stage was construction in 1953 of the center section basement with heating plant and fire alarm components. There is space here for future division.

The final phase was the center section, just completed, which joins the two wings. On the first floor are the offices of the Tax Collector, Board of Health, Board of Assessors, Building Inspector and Public Health nurse. The second floor contains the large, panelled Council Chamber with an office for the Mayor and a cloakroom.

The cost of the finished building is $310,086.66 with $57,098.43 for the east wing; $114,815 for the west wing; $34,956.43 for the center section basement; and $122,821.80 for the balance of the center section. Walter W. Jones was architect and John G. Albertson engineer.

Below are shown, left to right, upper photos, the Borough Clerk's business office, the Tax Collector's office, the Conference Room and the Police Department Desk.

You are cordially invited to inspect the Municipal Building
Sunday October 16, 1955 from 2 to 5 o'clock.

Mayor
H. GERARD MOERSDORF

Councilmen
FRANCIS G. DOMINICK LAWRENCE C. CABELL
CLIFTON D. NORRIS RITZIE A. DOFFEY
ARTHUR E. PFROMMER M. C. BELLAVIGNA

Borough Clerk
ROBERT I. RAFFORD

All Municipal Offices Are Now In
The New Hasbrouck Heights Municipal Building

This is a brochure showing the "new" municipal building around 1953.

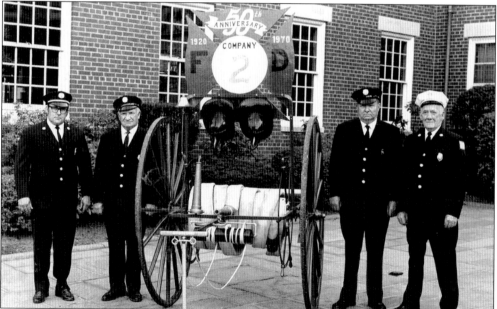

Pictured with the original hand-drawn hose reel are, from left to right, 1970 fire chief Albert Wistermayer, former chief George Eckert, former chief August Herkert, and 1970 deputy chief William Hale. This is the reel that Henry Lemmermann purchased for the borough in 1895. The reel was discarded when fire trucks were brought in as equipment. It was found in a barn and was refurbished by George Eckert and members of Engine Company No. 2.

30

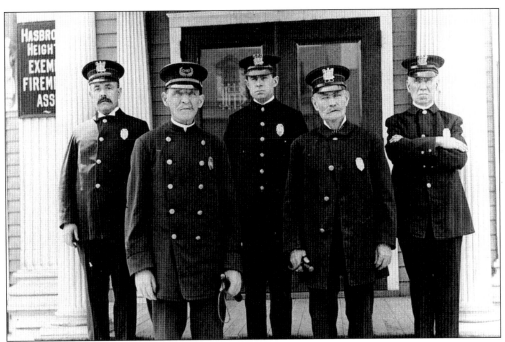

Pictured are members of the Hasbrouck Heights Police Department around 1920. From left to right are (first row) Chief Anthony Closterman and Edward Fitzgerald; (second row) Patrick Macqui, Albert Martin, and Mr. Cleary.

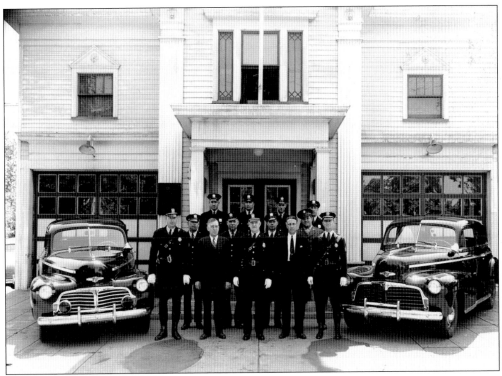

Members of the Hasbrouck Heights Police Department pose in the early 1940s.

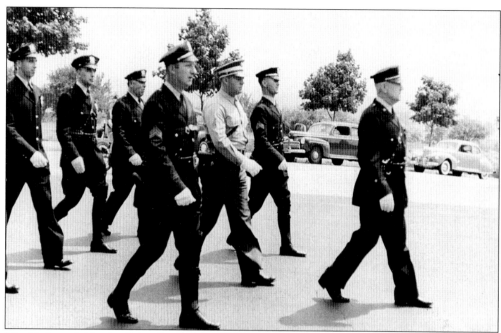

The Hasbrouck Heights Police Department marches in the 1942 Memorial Day Parade. Leading the parade is Chief Melville Hook followed by Sgt. Arthur Baker, George Gernert, and Sgt. Harry Carty. In the rear row are marshal Nicholas Van Dam, officer William Reisen, and Edward Beckman.

Police chief Harry Carty Sr. is shown with a future chief, then Sgt. Howard "Buddy" Baker, around 1965. (Courtesy of the Condal family.)

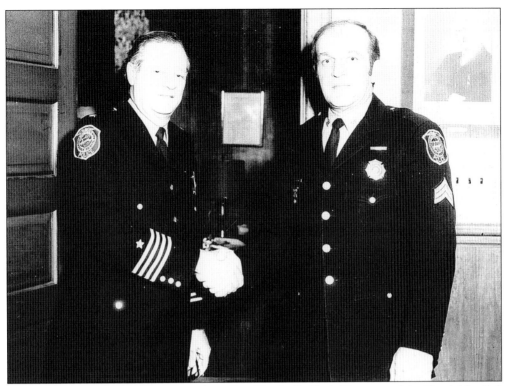

Chief Howard "Buddy" Baker congratulates Sgt. Charles Rafford. (Courtesy of the Condal family.)

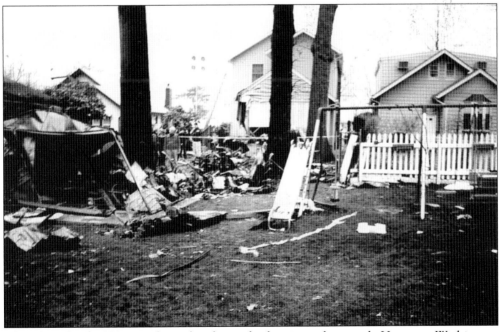

This December 9, 1999, view shows the aftermath of a private plane crash. Houses on Washington Place and Central Avenue were affected.

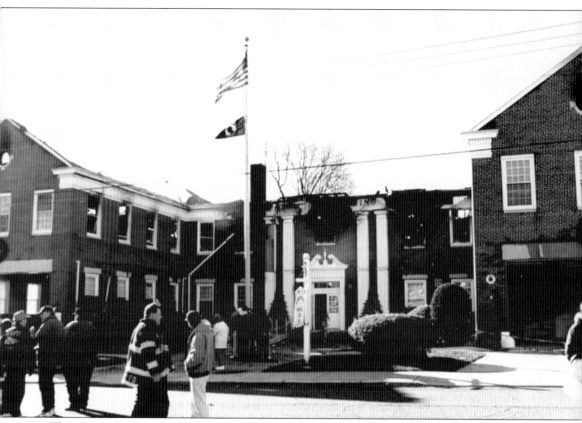

This December 11, 1999, photograph was taken the day after fire destroyed Borough Hall. Occurring so close together, this fire and the December 9 plane crash represent perhaps the worst two-day period in recent Hasbrouck Heights history.

Three

BUSINESS AND TRANSPORTATION

Grandview Boulevard, now known as the Boulevard, became the major thoroughfare in 1896. Numerous businesses have graced the streets of Hasbrouck Heights. Early banks were the Building and Loan Association and the Bank of Hasbrouck Heights. The building that housed the Bank of Hasbrouck Heights still stands at the corner of Jefferson Avenue and the Boulevard. In 1924, the Polifly Building and Loan Association opened and was in existence until 1994, when it was purchased by another financial institution.

Some of the popular businesses in this early time period were Ehler's and Meyer's grocery stores, Powelson's Drug Store, and Palmerie's Soda Shop. The community's only movie house, the Strand Theater, was also a popular destination. It was located at the corner of Franklin Avenue and the Boulevard. It was torn down in 1935 because of declining interest. New movie theaters were becoming popular. Allen and Allen Insurance Company, Fisher's Luncheonette, and Redford's are businesses that have deep roots in town.

The Old Homestead Restaurant had its beginnings in 1926. The building, a Dutch brownstone, which dates back to 1682, is one of the oldest surviving Dutch buildings in Bergen County. The brownstone foundation is two to two and a half feet thick. An addition was constructed in 1716, and the original property went all the way to Lawrence Avenue. The popular restaurant at one time had a club for its patrons called the Mustardeers. This group originated when three friends carved their names in mustard spoons used by the restaurant. The club reached its height of membership at 527 members. Local dignitaries and celebrities dropped by for a meal. Jersey City mayor Frank Hague even traveled to the restaurant for a bite to eat.

People received their news from various outlets. Alonzo Chamberlain began publishing the *Newsletter* in 1886, and in 1924, Percy Lester founded the *Hasbrouck Heights Observer*. The *Observer* is still published weekly.

The buzz in 1937 was the building of the Bendix Corporation across from Teterboro (Bendix) Airport. The factory, which made airplane engines, employed close to 3,000 people. Another airplane part maker was Air Associates. During the 1940s, labor strikes occurred here and soldiers were needed to quell the disruptions. The neighboring town of Wood-Ridge was one of the homes to the engine division of the Wright Aeronautical Company. Having the Wright Aeronautical Plant (Curtiss-Wright), Bendix, and Air Associates in the immediate vicinity

made for a worrisome time for residents during World War II. Due to the onslaught of cars from the Curtiss-Wright factory, traffic lights were installed on the Boulevard. Burton and Oak Grove Avenues and Wood Street were all made one-way so the cars would not use these streets as exits from Passaic Avenue. With the construction and improvements to Route 17 by the Department of Transportation, the traffic moved up to Terrace Avenue and the Boulevard. Both thoroughfares became quite hectic.

As with all the Bergen County towns, the trolley played an important role. The Hudson River Trolley tracks ran down the Boulevard connecting Newark, Rutherford, and Hackensack. The yellow trolley was electrically operated. The trolley had a cowcatcher to remove objects on the tracks, and during the winter, it had a plow in front. Around 1913, after nearly five years of discussion, the Boulevard was paved. The tracks were finally removed in 1942 in order to use the steel for World War II. The demise of the trolley line promoted development of bus lines. One line on the Boulevard went to New York City and another to Englewood. Terrace Avenue's line ran to Newark.

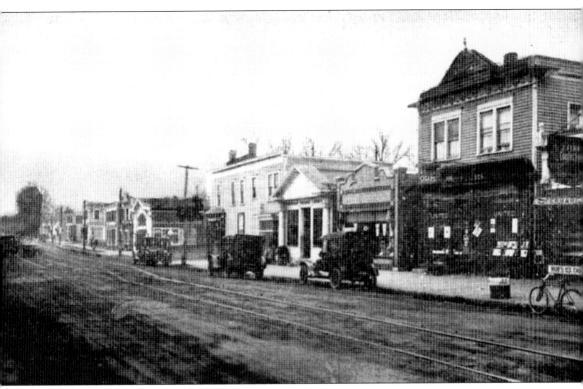

The Boulevard is shown in the 1920s.

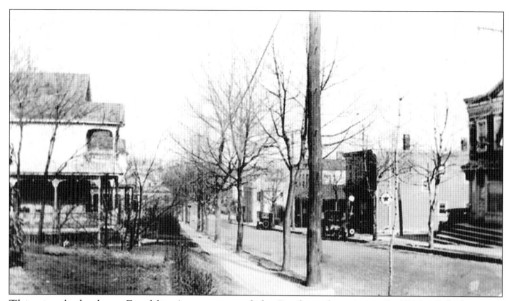

This view looks down Franklin Avenue toward the Boulevard in the early 1920s. Schultz's Gas Station is on the right-hand side.

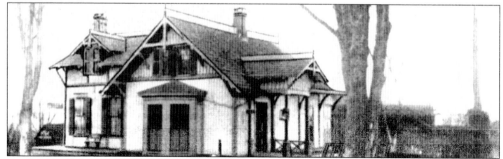

Zapf's Hotel, now the Ivy Inn, stands on Terrace Avenue around 1910.

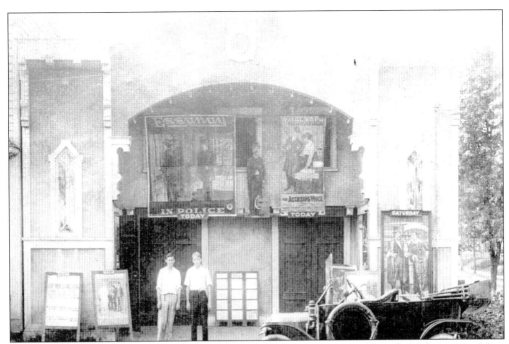

The Strand Theater, nicknamed "the monkey house," is pictured in the early 20th century. Now playing: "Giant Man-Eating Shark" short film and a Charlie Chaplin movie.

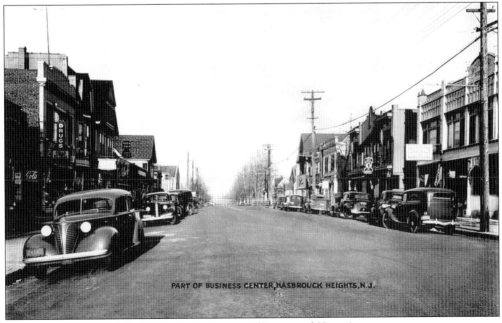

PART OF BUSINESS CENTER, HASBROUCK HEIGHTS, N.J.

This 1930s scene is of the Boulevard between Jefferson and Kipp Avenues.

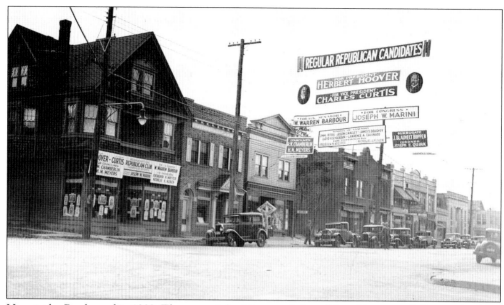

Here is the Boulevard in 1932. The scene is looking south from Kipp Avenue to Jefferson Avenue. Republican Herbert Hoover went on to lose the election to Democrat Franklin Roosevelt.

A bond rally is held around 1944 at the corner of Franklin Avenue and the Boulevard.

Here is another view of the bond rally. It was taken at the corner of Franklin Avenue and the Boulevard.

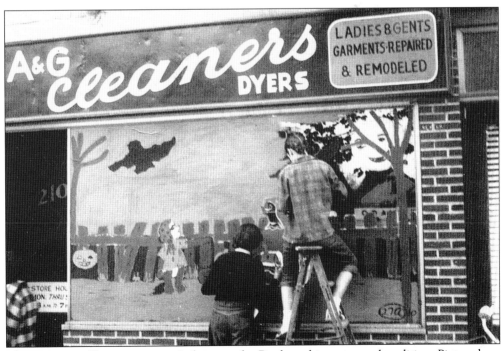

The painting of business store windows on the Boulevard is an annual tradition. Pictured are Jean Padberg and Liz Rice painting the window of A&G Cleaners in October 1951.

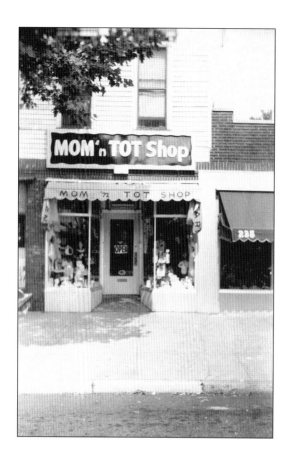

The Mom and Tot Shop was located on the Boulevard in the mid-1940s.

Shown is the corner of Franklin Avenue and Third Street (now Oldfield Avenue) around 1920. In between the houses one can see the absence of development on Route 2 (now Route 17).

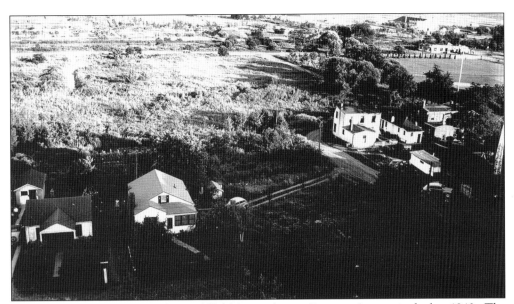

Houses stand on Third Street (now Oldfield Avenue) near Garrison Avenue in the late 1940s. The field is now the location of the Hasbrouck Heights Swim Club and Little League Baseball fields.

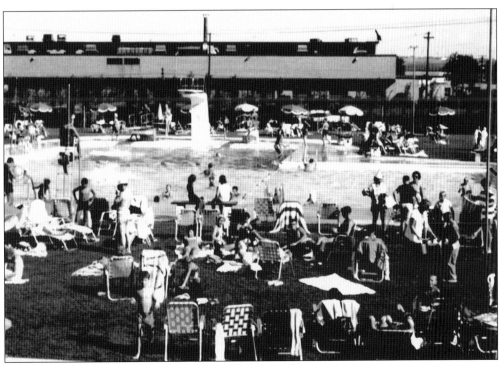

In July 1961, the Hasbrouck Heights Swim Club opened.

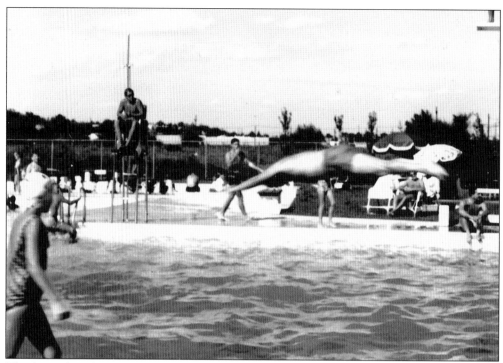

The diving board is in use during opening day of the Hasbrouck Heights Swim Club.

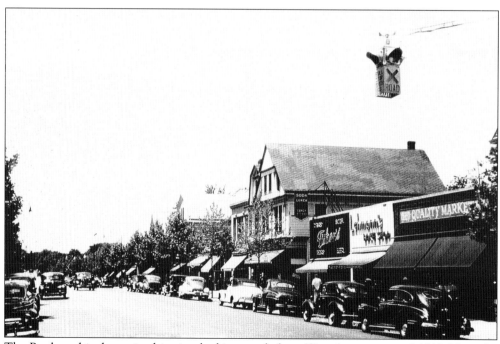

The Boulevard is shown in this view looking south from Kipp Avenue around 1940. Note the traffic light in the top right and the size of the trees. Fisher's Luncheonette is located in the center right.

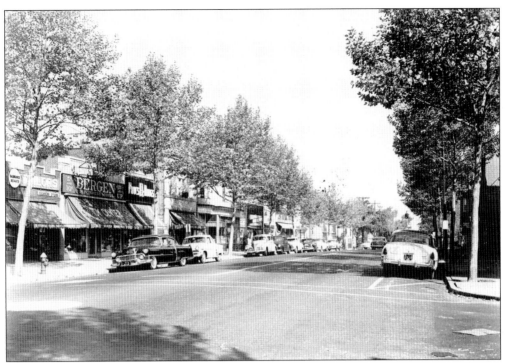

The Boulevard is pictured in this 1950s view, which was taken looking north from Jefferson Avenue. The Bergen Department Stores 5 and 10 and Paul's Drug Store are to the left.

A similar scene shows the Boulevard south from Kipp Avenue in 1975. The trees have grown, and the flashing light has been replaced.

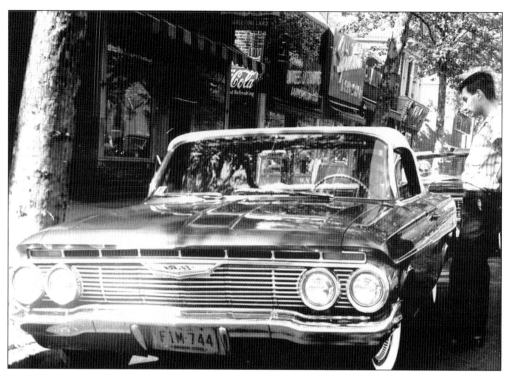

An admirer of an early 1960s Chevrolet Impala discusses the news with the owner on the Boulevard between Kipp and Jefferson Avenues.

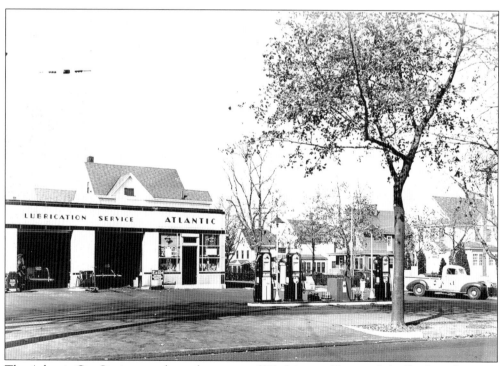

The Atlantic Gas Station stands on the corner of Washington Place and the Boulevard.

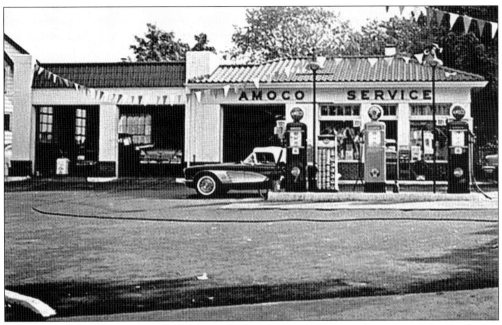

Otto and Al's Amoco is open for business on the corner of Williams Avenue and the Boulevard in this photograph taken in 1960. Today, the garage is a BP gas station. (Courtesy of Al and Marie Smith Deppe.)

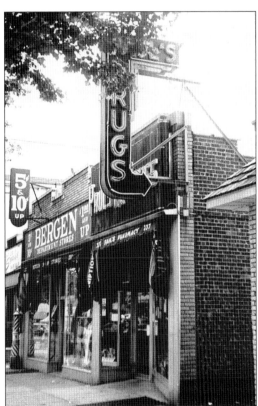

Shown are the Bergen Department Stores 5 and 10 Store, and Paul's Drug Store on the Boulevard around 1965.

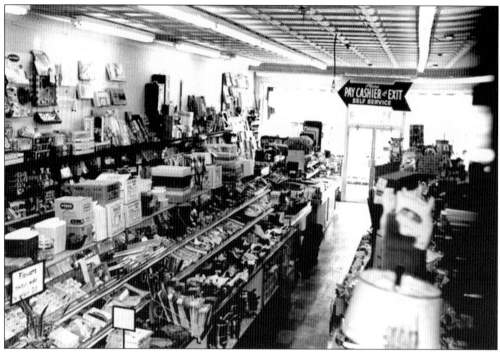

This 1960s view shows the interior of the Bergen Department Store 5 and 10.

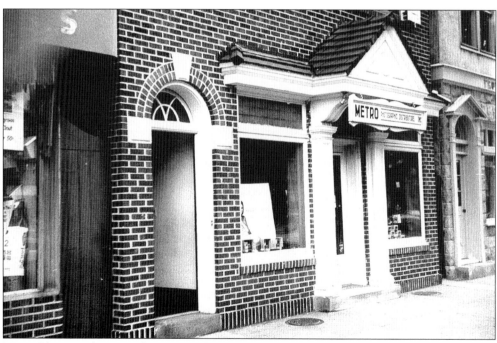

Metro Photographic Distributors stands near the corner of Kipp Avenue and the Boulevard. Later, around 1970, this business moved across the street, down by Jefferson Avenue.

Kent Cleaners stands on the corner of
Kipp Avenue and the Boulevard in 1975.

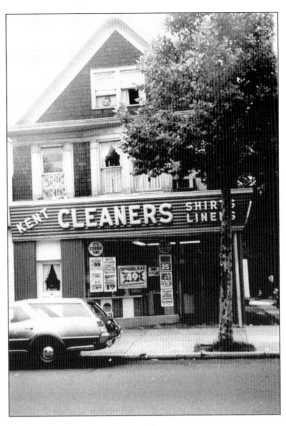

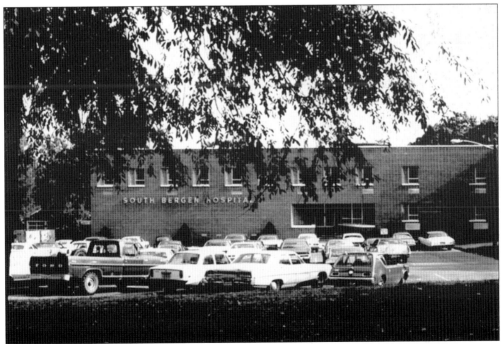

South Bergen Hospital is pictured in 1975.

Old Homestead Restaurant

●

Full Course
 Sunday Dinner . $1.00

Blueplate Dinner
 Sunday & Daily 50c

Daily Luncheon . . 65c

SPAGHETTI
TO TAKE HOME

OLD HOMESTEAD
Kentucky Straight
Bourbon
3 Years Old

qt. $2.35 pt. $1.20

●

Your Host
"Jimmie" Trepicchio"

307 TERRACE AVE.
Hasbrouck Hts. 8-0499

These advertisements appeared in the 1939 *Observer*. Note the prices for a dinner at the Old Homestead Restaurant.

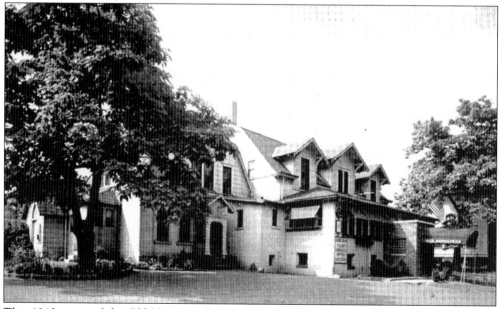

This 1940s view of the Old Homestead shows that the place has not changed much over the years. Today, it is Sylvester's.

This is an advertisement for Fisher's Luncheonette on the Boulevard.

This 1947 advertisement is for G. Depken and Sons Oil Company.

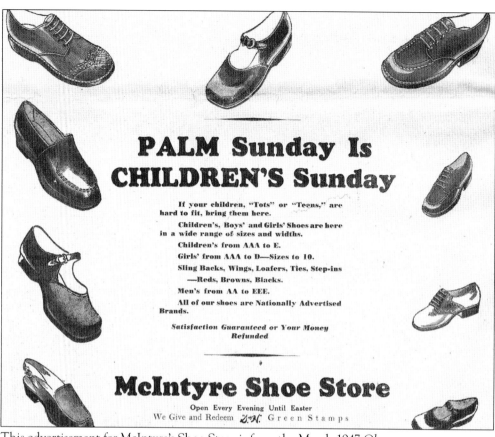

This advertisement for McIntyre's Shoe Store is from the March 1947 *Observer*.

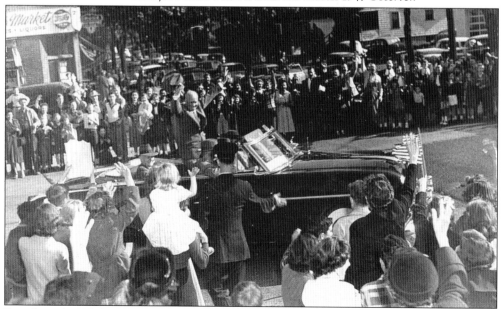

Presidential candidate Dwight D. Eisenhower campaigns in Hasbrouck Heights in 1952. The photograph was taken at the corner of Williams Avenue and the Boulevard.

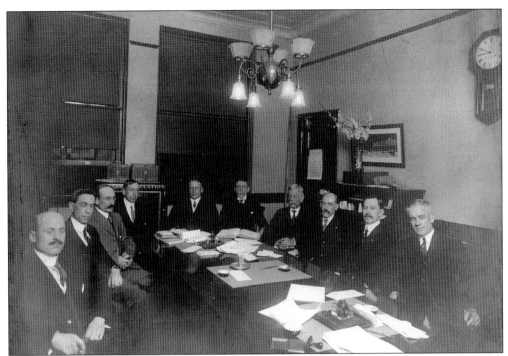

Members of the Hasbrouck Heights Building and Loan Association's Board of Directors are, from left to right, Theodore Ruckert, George Hastings, G. W. Stanton, Will D. Martin, Frank Flagg, Pres. John Martin, district clerk Mr. Roberts, William Wheeler, Clarence Hoffman, and Frank Pace.

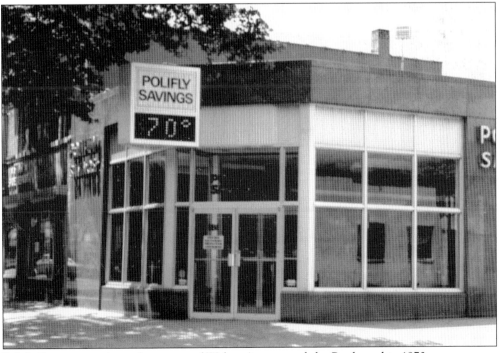

Polifly Savings stands on the corner of Walter Avenue and the Boulevard in 1970.

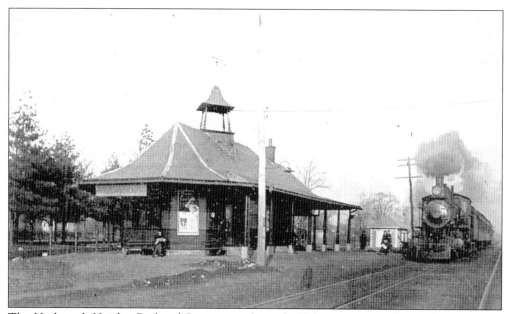

The Hasbrouck Heights Railroad Station, in the early 20th century, was located near what is today Route 17 and Franklin Avenue.

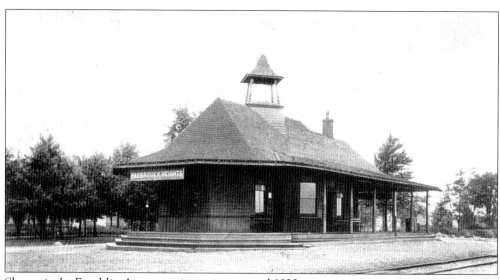

Shown is the Franklin Avenue train station around 1920.

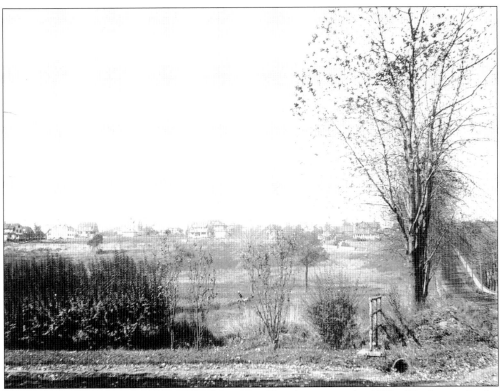

This is known as "the Commuters Climb" up Franklin Avenue in the 1920s. The houses in the distance are on Berkshire Road.

This view looks up from the railroad tracks, near present-day Route 17.

These trolley tracks run along the Boulevard, possibly near Raymond Street, around 1915. A closer look reveals the trolley car in the far distance.

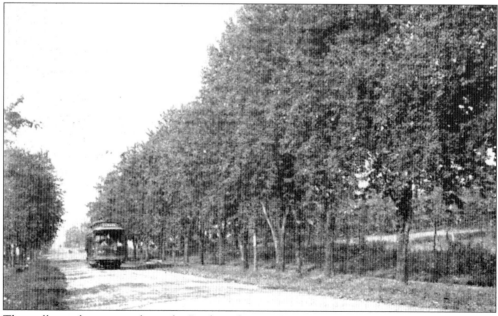

The trolley makes its way down the Boulevard in 1915.

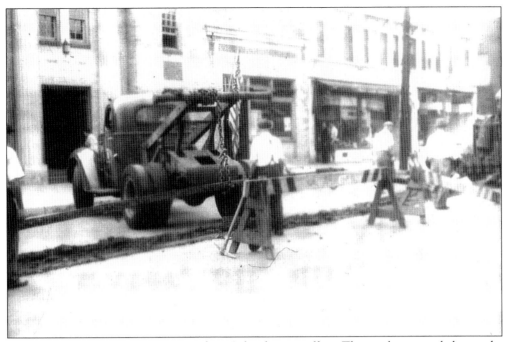

The trolley tracks are torn up around 1943 for the war effort. The steel was needed to make tanks and other war machinery for World War II. Note that the negative was reversed during the printing of this photograph.

A mother and child await the bus at the corner of Division and Terrace Avenues in the 1940s.

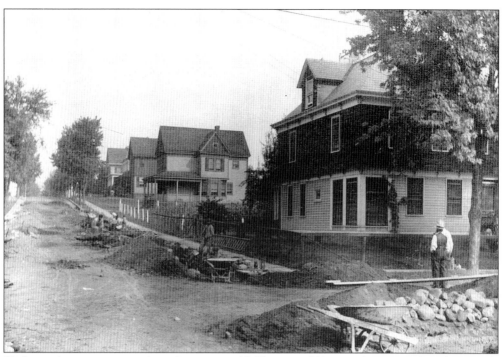

Curbs are being constructed on the corner of Jefferson and Burton Avenues. This photograph was taken looking west around 1913.

Again looking west, here is another view of the curb construction on Jefferson and Burton Avenues. Note the men in the ditch and the lanterns.

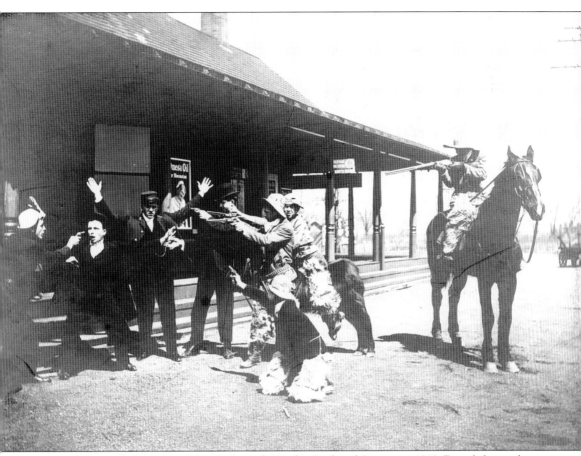

Pictured is a mock shoot-out at the Hasbrouck Heights Railroad Station in 1910. From left to right are Harold Bangs, John Southwick, Mr. Thoma, Fred Gross, Warren Crane, and Walter Baker. Note the two gentlemen sitting on the Shetland pony. Today, students in Erin Schneeweiss's drama class at the high school create movie scenes like this as part of class projects.

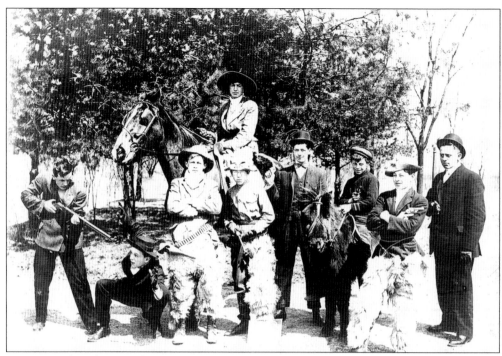

Here is another photograph of the mock shoot-out.

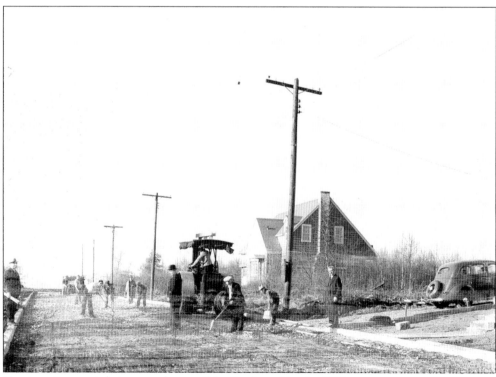

Harrison Avenue is being paved west of the Boulevard in the 1930s.

This photograph was taken from atop the Beacon Towers on Terrace Avenue in 1941 by Walter Field. The man in the picture is Miles Reese. Notice the lack of development in the background. (Courtesy of Elsie Ardito Sternbach.)

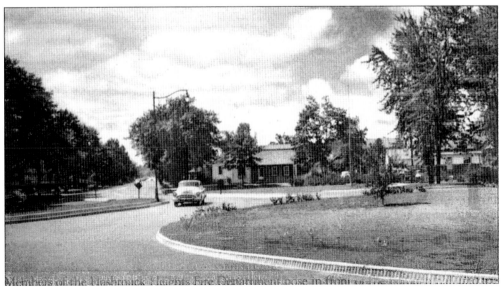

The Boulevard traffic circle is pictured in the 1950s.

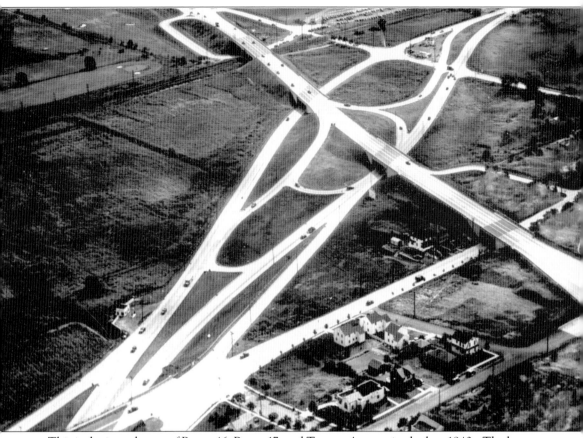

This is the interchange of Route 46, Route 17, and Terrace Avenue in the late 1940s. The houses are near Baldwin and Pasadena Avenues.

Four

PRE-1920 SCHOOLS

The first school is believed to have stood on Passaic Avenue west of Polifly Road and was used until the 1840s. A private school was in existence in the early 1800s, but attendance was limited to wealthy families. This school was held in a home that was to become the Old Homestead restaurant, now Sylvester's. Families also sent their children to Wood-Ridge to be educated.

In the 1880s, a school was built on the southeast corner of Washington Place and Burton Avenue. The First Reformed Church is now located there. The school was completed in 1882, and Eleanor Speer was the first teacher. She would walk from her home in Rutherford to the Carlstadt train station, disembark at the Corona station, and walk up Ravine Avenue to the school.

A growing enrollment saw an addition built in 1891. It served until 1896, when the need for larger quarters again necessitated a new building. Many of the town's church and civic organizations met in the school. The "old" school was sold to St. John the Divine Episcopal Church for $100. A stipulation was that the building was to be moved to Jefferson Avenue within 15 days. The building would still be used as a school for the remaining year while a new one was built on the old lot. However, there were problems with the building of the new school. It was not placed in the proper area, and eventually the builder went bankrupt. Children attended class in the Pioneer Club and the Episcopal Church. Finally, in January 1897 the new school was completed. Although it had one more room than planned, it also soon proved to be inadequate.

During a blizzard on January 25, 1905, fire struck the schoolhouse, which was in session. Residents trudged through the snow fearing for the students' safety. Because of the storm only 150 or so students were in attendance, and with the fire's quick discovery, no one was hurt. The fire department had an extremely difficult job getting the fire equipment to the school. The Hook and Ladder arrived, but the Hose Company never made it. It was stranded a few blocks from the fire. When the fire department arrived, the inclement weather and low water pressure made it difficult to extinguish the fire. Once they were certain all the children were safe, the firefighters were able to prevent the fire from spreading to adjoining houses but were unable to save the structure.

This fire, having destroyed the only school, brought about the construction of Franklin School. However, the Board of Education had a much more immediate problem—where to hold school in the interim. At this time various churches, the Pioneer Club, and the Borough League Building (the former library on Division Avenue) were all utilized.

In 1906, bonds were issued to buy land for the new school on Franklin Avenue. Ground was broken in March 1906. The school was already in use for a month before it was formally dedicated on December 4, 1906. By 1911, Franklin School was already overcrowded, but a proposal to expand it was defeated. Two years later another proposal was put forth with seven questions on the ballot. Only the last two questions about borrowing money and issuing bonds passed. The

newspapers reported that people must have forgotten to write in no for these two questions. The Board of Education was then authorized to borrow money and issue bonds, but they could not purchase land or build a new school. In 1914, the voters approved the board's proposal to buy land on Paterson Avenue and on Passaic Avenue. Two new schools were to be built on these properties. Only five percent of the voters turned out and 62 ballots were cast. Euclid and Lincoln Schools (twin schools in layout) were completed in October 1915.

A Hasbrouck Heights grammar school class poses for a photograph in 1900.

This class photograph was taken about 1903.

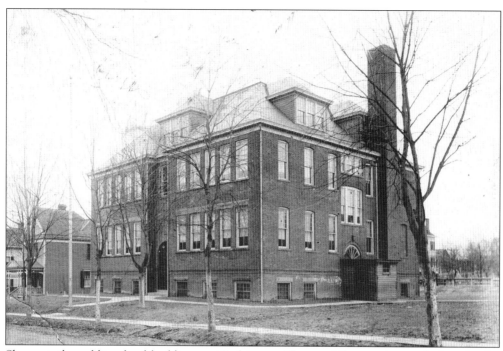

Shown is the public school building on Washington Place and Burton Avenue before the fire of 1905.

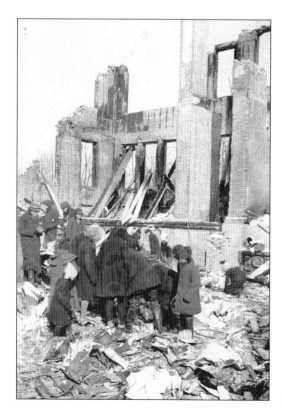

Children rummage through the remnants of the fire that destroyed the public school located at Washington Place and Burton Avenue on January 5, 1905.

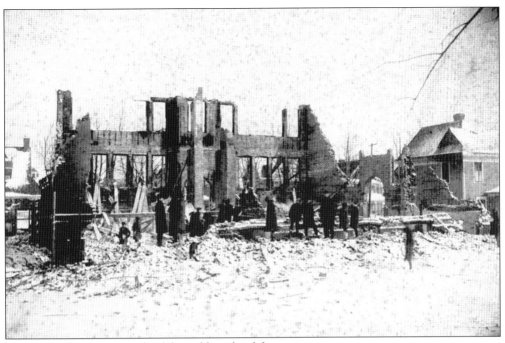

Here is another photograph of the public school fire.

This is a class at Franklin School around 1907.

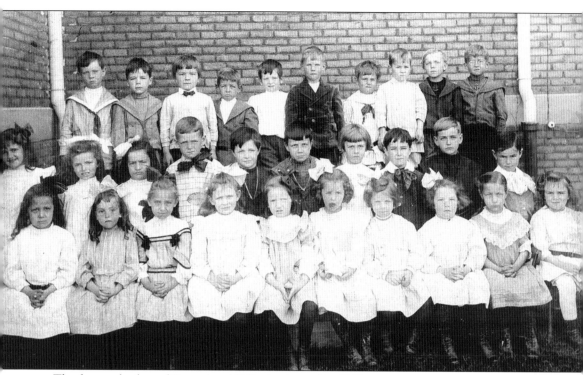

The first-grade class of Genevieve Giblin is pictured in 1909.

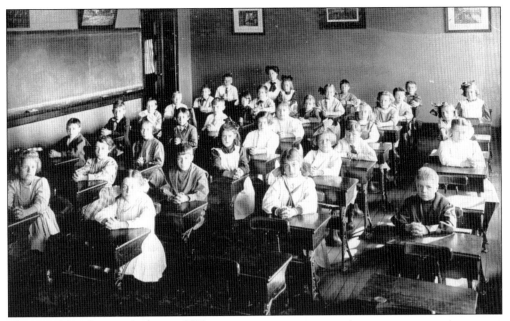

Shown is Miss Seymour's class in 1911.

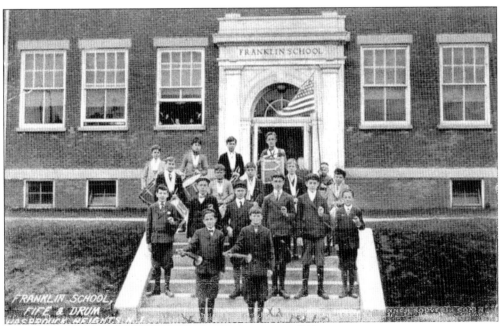

The Franklin School Fife and Drum Corps tunes up in 1910.

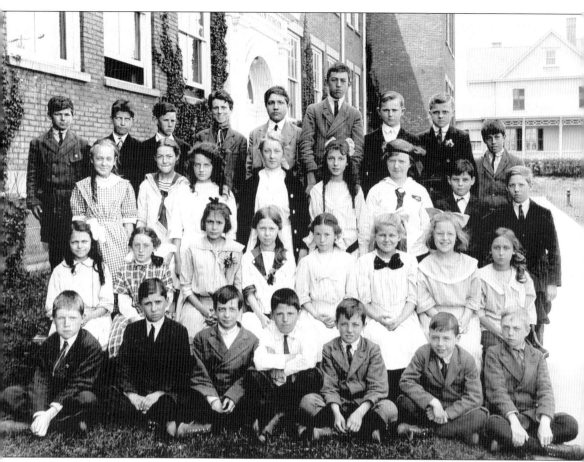

Here is Mrs. MacMurray's sixth-grade class at Franklin School in 1914.

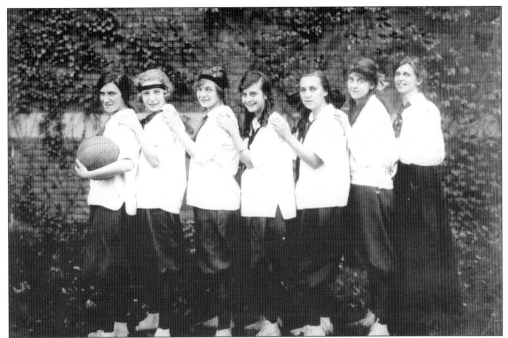

The first girls' basketball team for Hasbrouck Heights poses in 1915. From left to right are Elizabeth Keogh, Lottie Lorenzo, Ruth Williams, Madelena Scherner, Ethel Storch, Marion Hastings, and coach Miss Naderbill.

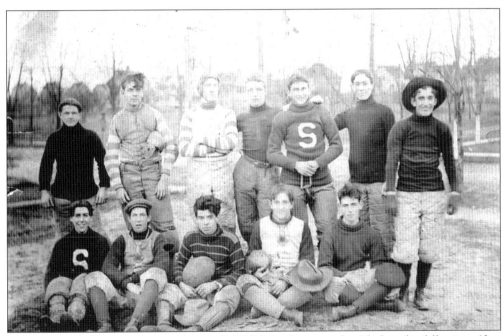

An early football team is pictured around 1915. Members are identified as the following: (first row) George Steinert, Mr. Taggart, Sumner Lawrence, Dan Bazire, and Gene De Voy; (second row) unidentified, Frank Hutchinson, unidentified, Will Scott, Milton Alexander, Fred Martin, and Steven Averill.

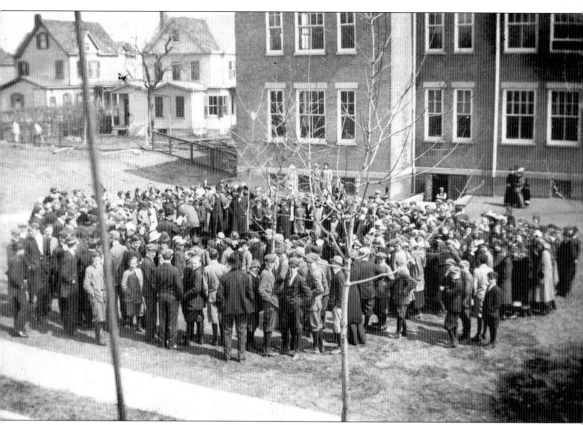

Arbor Day is celebrated at Franklin School in 1915.

Five

POST-1920 SCHOOLS

Between 1920 and 1930 the population of Hasbrouck Heights increased 99 percent, which meant the schools needed additions. In 1923, rooms were added to the elementary schools, and the Franklin Gym was built on Hamilton Avenue. The expansions, however, again proved to be inadequate.

In 1928, the Board of Education suggested purchasing land from the borough to create the athletic field, as opposed to renting Lemmermann Park (Central and Oak Grove Avenues). With the consent of the people, the Board of Education purchased the present-day Depken Athletic Field for $4,000. In 1929, the Board of Education proposed a new school to be located on Terrace Avenue between Columbus and Cleveland Avenues with a cost of $675,000; this was to be a regional high school with Wood-Ridge. The proposal, however, was voted down by a margin of nine to one. A few other proposals were made such as buying Lemmermann Park or building on Oldfield Avenue (then known as Third Street). By 1930, the situation had become desperate. The election was held, and the proposal won by two votes, but with such a close vote, a recount was in order. Four previously rejected ballots were now accepted, three with a no vote and one with a yes vote. This turn of events caused a tie, which then voided the election. By fall the situation had become even worse. The Board of Education resubmitted the Oldfield (Third Street) proposal, and again it failed by 291 votes. Portable classrooms were turned down, and a plan to add six rooms to both the elementary schools and Franklin School failed by 56 votes. Finally, after eight years, additions to the schools began in 1933. A proposal in 1936 to complete the athletic field was defeated. In 1938, with a contribution by the Works Progress Administration (WPA), this proposal passed and the athletic field was finally completed.

There was discussion of a high school in the 1920s and 1940s, and again possibly regionalization with Wood-Ridge. Only in the early 1950s did serious discussion begin regarding the building of a new high school. Disagreements about sites occurred, but finally the location between Paterson and LaSalle Avenues was chosen. The borough owned the land and donated it to the Board of Education. Temporary veterans' housing had been situated in this area. In January 1951, a special election was held to vote on the $835,000 bond question. The Taxpayer Association was against construction and campaigned heavily to defeat it. When the election was over, the yes votes were up by 15, and the Taxpayer Association wanted a recount. The yes votes came out on top again, and construction began. Hasbrouck Heights High School was dedicated on January 25, 1953. In the late 1950s, the addition of an all-purpose room was completed. By the 1960s, an addition was built at the high school, creating the English wing, as well as science labs in the 1970s. In the early 1980s, regionalization with Wood-Ridge was again discussed. Another

proposal to build a new school where Franklin School was located, failed. So, in 1984, a proposal for expanding the high school—to include sixth, seventh, and eighth grades, an auditorium, and cafeteria—commenced. Bids came in too high, and the plans needed to be redesigned. The addition was completed and was opened in September 1987. Hasbrouck Heights is also home to a montessori school and the successful Kathy Dunn Cultural Center, which has offered preschool, both half and full day, and accredited kindergarten for nearly 30 years.

In the 1990s, regionalization with Wood-Ridge again became an issue. Committees were created in 1993 and 1996 to discuss the proposals. An actual vote was taken in 1993, and the proposal was defeated. In 1997, another vote occurred and the proposal was again defeated, thereby ending all discussion of regionalization. With population on the rise, additions to all the district schools commenced in 2000 and were completed in 2002.

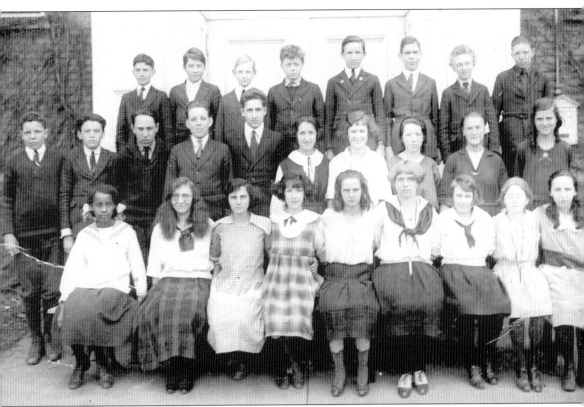

Pictured are the Euclid School's seventh- and eighth-grade classes of 1921–1922. Long time Hasbrouck Heights educator Mary Quigg was the teacher. From left to right are (first row) Evelyn Baker, Lilly Eckert, Blanche Gang, Jennie Los, Florence Lavender, Anna Lau, Mary Gaffney, Katherine Duerloo, and Mildred Barthold; (second row) Donald Bell, Robert Caldwell, Arthur Barthold, Walter Coney, John Buell, Marabelle Erickson, Marjorie Bradford, Anna Kowell, and Jannette Brightly; (third row) Joseph Feinstein, Edward Church, Wilbur Kupfrian, William King, George Eckert, Vernon Conant, Adrian Duerloo, and August Herkert.

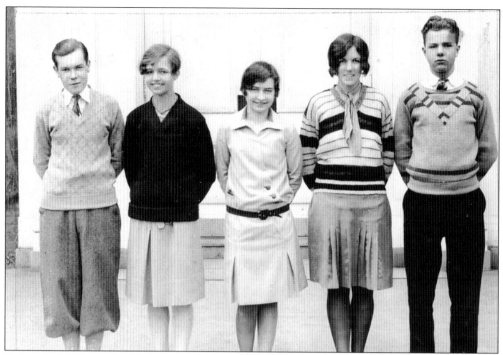

Posing in 1928 are the Hasbrouck Heights cheerleaders. From left to right are Elbert Bedell, Roberta Kellers, Alice Norris, Audrey Montgomery Burr, and Ralph Kiel.

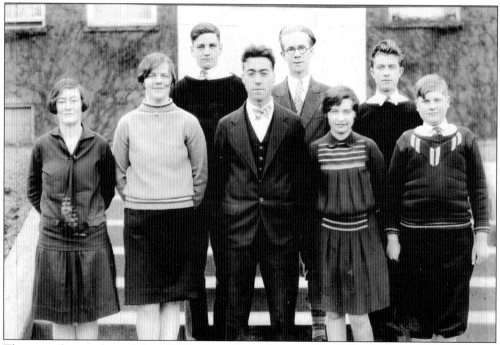

These are the members of the 1928 Student Council at Franklin School. Pictured are (first row) Margaret McKenna, Margaret Wenthea Haupt, Richard Pagano, Alice Norris, and Lawrence Zahn; (second row) Franklin Rogers, Wesley Edwards, and Anthony Steinert.

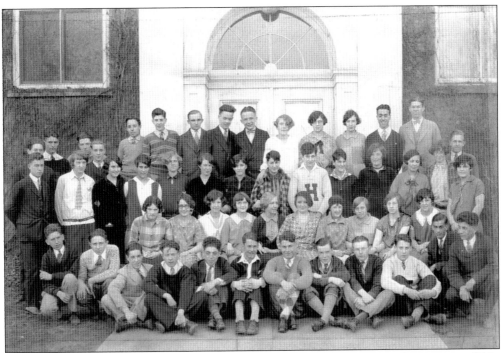

Members of the Franklin School class of 1928 pose for a photograph in their sophomore year, 1926.

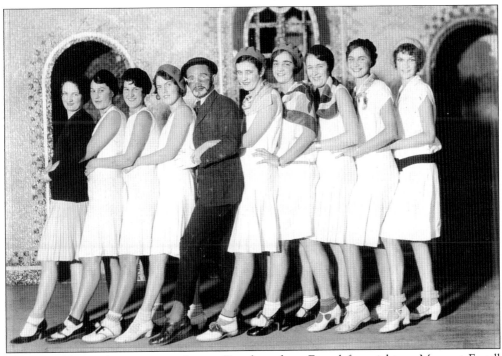

The 1930 Alumni Association produces a Broadway show. From left to right are Margaret Farrell Kraus, Irene Palmer Padberg, Helen Biddle Mentes, Hilda Freberg Caddoo, George Eckert, Clara Coutant Pagano, Helen Dubois, Nanette Coutant Capell, Violette Ruegger, and Evelyn Heimsoth.

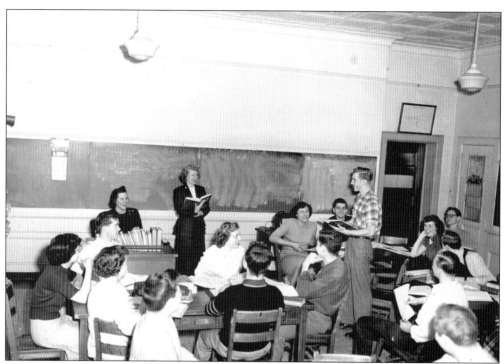

At Franklin School, members of this 1951 English class have Bernice (Gertcher) Bartlett and Ms. Baker as teachers.

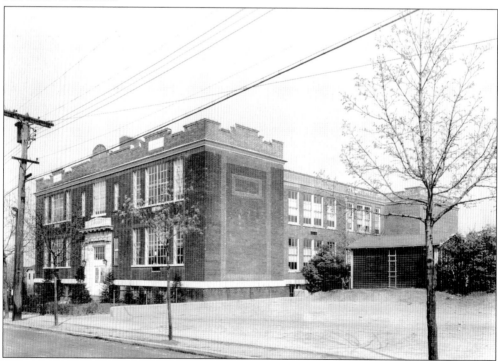

Lincoln School, one of the twin elementary schools, was built in 1905. It is pictured here in the 1940s.

The other twin elementary school, Euclid, is shown around 1940. Technically, the school facades are slightly different, but the floor plans are the same.

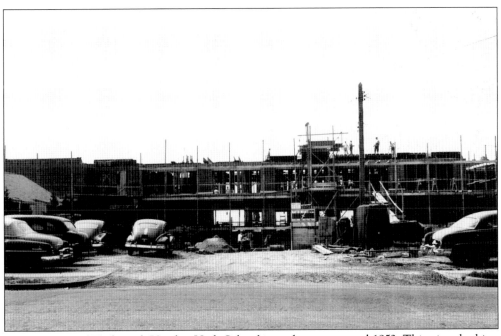

Construction of Hasbrouck Heights High School is under way around 1952. This view, looking toward the front of the building, was taken from the Boulevard.

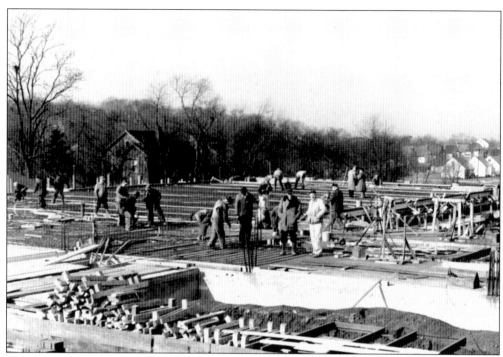

The construction crew works on building the second floor of the high school in 1952.

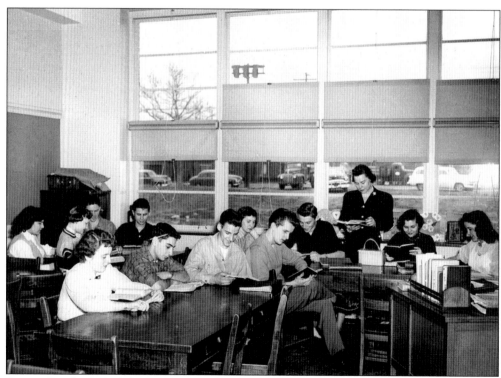

Bernice Bartlett's English class poses in the new high school in 1955.

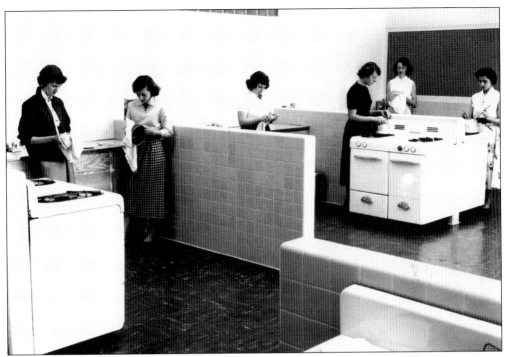
In the new high school, the home economics class cooks and cleans up in 1955.

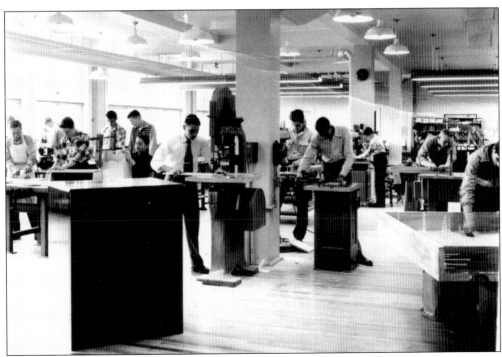
Also in the new high school, the industrial arts class saws wood in 1955.

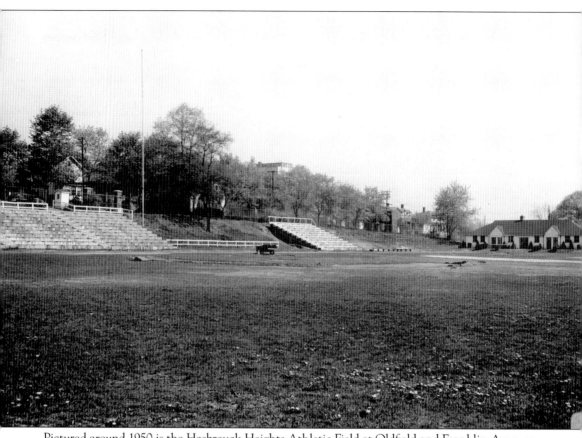

Pictured around 1950 is the Hasbrouck Heights Athletic Field at Oldfield and Franklin Avenues.

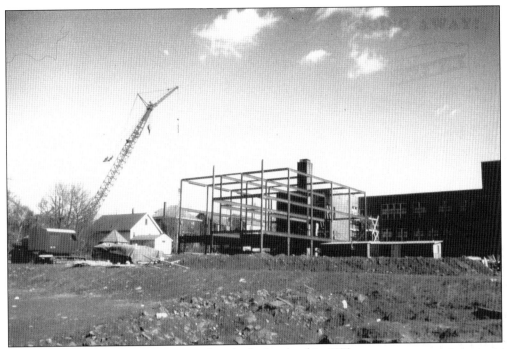

The science lab addition is constructed at the high school in 1973.

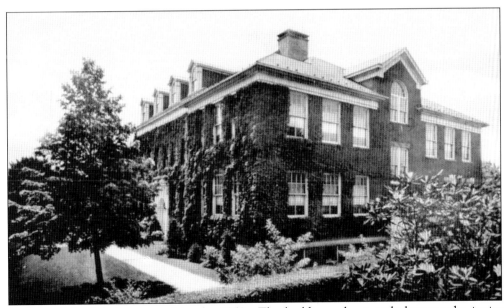

Franklin School is ivy covered in the 1950s. The building subsequently became the junior high school.

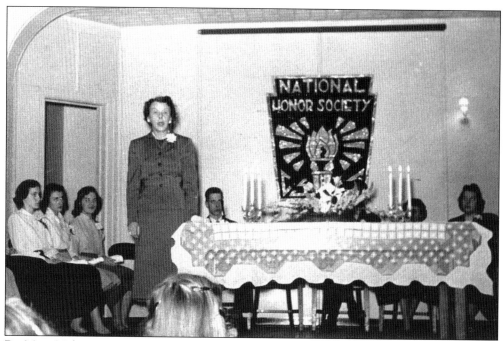

Dr. Mary Mohair, principal of Franklin School, the high school, and a future superintendent of schools, makes the opening remarks at the candlelight ceremony of the National Honor Society induction around 1950. (Courtesy of Bernice Bartlett.)

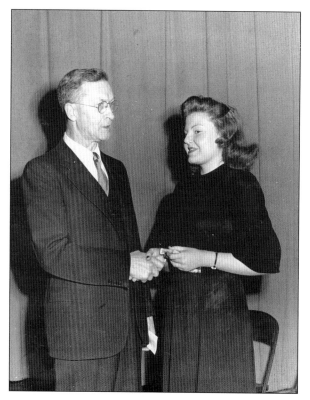

Dr. Clarence Hitchcock, superintendent of schools, presents a Forensic League Medal to Florence Hyland in the early 1950s.

Good-bye Mrs. Bartlett

After many years of service to both the community and Hasbrouck Heights High School, Mrs. Bernice Bartlett, English teacher and Speech Coach, has resigned effective the end of the school year.

During her long tenure at HHHS, Mrs. Bartlett has served as advisor to the National Honor

Top Honors

Mark Cohen is the valedictorian of the class of 1974. When asked how it felt to graduate first in his class, Mark said that he never really gave it much thought, but that he considers it a nice honor. In the fall he will be enrolled in a freshman honors program at the University of Iowa, where he will major in journalism. Mark was the editor-in-chief of the **Pilot** this year. This outstanding senior's major interests are watching hockey (he's a season ticket subscriber to the Rangers), listening to folk music, and watching old movies on television. Mark maintains a collection of books on old movies and records of old radio

Charles Francavilla. Charles said, "It's a pretty good feeling, but I'm not overwhelmed. I care more about the grades for college". Charles will be attending Georgetown University, and then he hopes to enter a school of dentistry. His hobbies are sports (basketball in particular), television, and chess.

Third place honors go to Cheryl Buchmuller, who will attend Fairleigh Dickinson University. Cheryl declined to be

interviewed by the Pilot.

The top 10 percent of the senior class is as follows: Mark Cohen, Charles Francavilla, Cheryl Buchmuller, Bonnie Nayda, Perry DelPurgatorio, Christopher Frith, Mary Jennings, Yvette Weisser, Laurie Esposito, Kathy Lysiak, Marisa Viscelli, David Van Dam, Lesley Gudehus, Sylvia Barsotti, Richard Mitchell, Nancy Cuomo, Linda Adam, Ann Kunigonis, Debbie Azzalina, and Tracey

Jordan.

The Pilot congratulates all for a job well done.

The theme for graduation will be "Reflections", as it was for the senior prom. Salutatorian Francavilla will greet the address on "Reflections on our School years". Cheryl will reflect on "Reflections on Personality", and Mark will say farewell with comments on "Reflections on the Future."

Shown is the June 1974 *Pilot*. The high school newspaper later became the multiple award-winning *Pilot's Log*, under advisers Lora Geftic and Gary Pankiewicz.

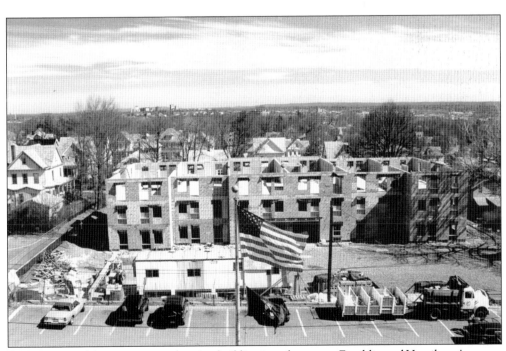

Construction of the senior citizen housing building is under way on Franklin and Hamilton Avenues. The antiquated Franklin School was torn down to make way for the housing around 1990.

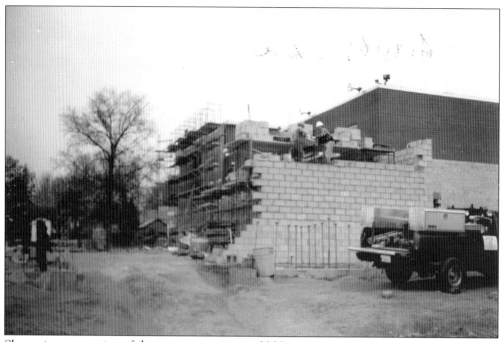

Shown is construction of the new gymnasium in 2000.

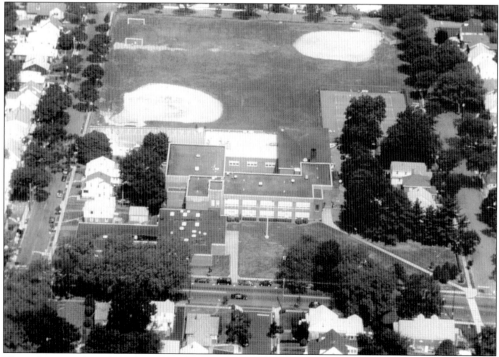

This photograph, taken from an altitude of some 1,200 feet, shows Hasbrouck Heights High School before the 2000 addition. (Author's collection.)

Six

CIVIC AND SOCIAL ORGANIZATIONS

The Pioneer Club on Jefferson Avenue was established in 1891 to provide social activities for Borough residents. In its early years, two of its clubhouses burned down. Each time it was rebuilt bigger and better than before.

The Field Club was formed in late 1891 with the same mission as the Pioneer Club. The Field Club chose land at Division Avenue and the Boulevard for its clubhouse location. However, it burned down before it was occupied and a new building had to be built. It is now home to the Masonic lodge. Another men's association, the Business Mens' Association, was formed in 1900 as a civic organization. Fraternal organizations such as the Royal Arcanum, American Mechanics, and the Modern Mechanics were popular in town.

In May 1901, the Borough League was founded with the mission of promoting culture, the arts, literature, science, and music. The Borough League was also to provide maintenance of the buildings that would house these cultural offerings, and also to create a library. Its building is still located on Division and Burton Avenues. The Borough League transferred the property to the Board of Education in 1915. The Board of Education then moved its lending library from Franklin School and combined it with the Borough League's books, thereby creating the Free Public Library. The Masonic Lodge now uses the property for a Masonic Learning Center to help dyslexic children learn to read better. The property is part of the Black family estate. It was given to Hasbrouck Heights to be used only for education. If not used for this purpose, the property reverts back to the estate.

Lemmermann Park played a great part in local civic organization activities. The park was located at the end of Oak Grove (which stopped at Central Avenue) and Central Avenues. It was utilized by all local groups and played an important part in providing the early recreation of the town. Originally, this densely wooded park with its beautiful flowers was difficult to enter because of a body of water. Lemmermann's installation of pipes removed the water, thus creating a brook. The park had two tennis courts, an ash/cinder running track, and sandboxes and swings for children. Mr. Birchen, a Central Avenue resident took care of the property. Lemmermann offered to sell the property to the borough, but the borough declined. The Pioneer Club soon purchased the park and continued to use it for recreation. In the 1930s, houses were constructed on the property.

At the end of the 1930s, the Friendly Neighbors group was formed. This group provides food and emergency help for families in need. Two representatives from each church make up the board.

The Woman's Club was formed in 1922 and the Junior Woman's a short time later. One very unique organization, REACH (Refugee Ecumenical Assistance Committee of Hasbrouck Heights), established only a few decades ago, assists elderly residents with rides to medical appointments. The year 1931 saw the founding of the local International Lions Club. This service organization, which is made up of men in the community, helps various local programs with funding. The group was instrumental in purchasing the land where Woodland Park exists and in constructing the comfort station and pavilion. The Lion's Club also provides the annual Fourth of July fireworks show and donated the lights on Depken Field.

The Kiwanis Club, which has been in town over 50 years, is another service organization. It is open to both men and women. The Elks Club has also served the borough for more than 50 years. In the early 1950s, the Leisure Club, composed of senior citizens, was formed. The club was founded by Ruth Mason and Helen Wilkins, both longtime residents. Today, there are over 200 members.

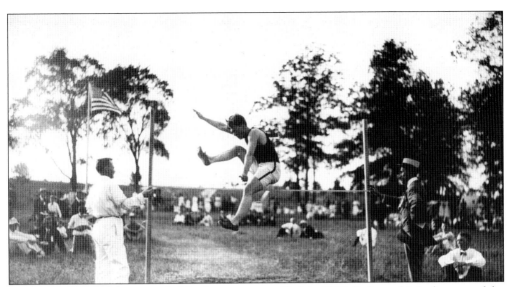
A Fourth of July celebration is held at Lemmermann Park in 1915. Perhaps this is the start of the Hasbrouck Heights track and field dynasty.

A long jump competition is part of the Fourth of July celebration at Lemmermann Park in 1915.

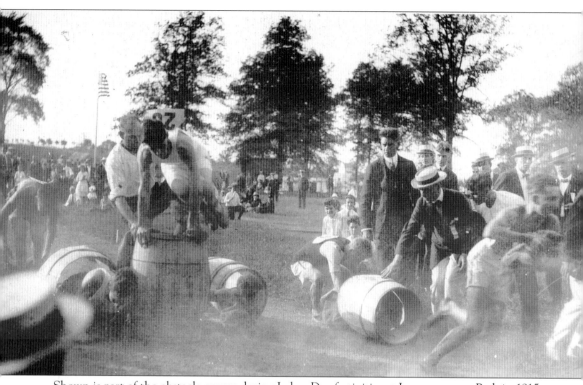

Shown is part of the obstacle course during Labor Day festivities at Lemmermann Park in 1915.

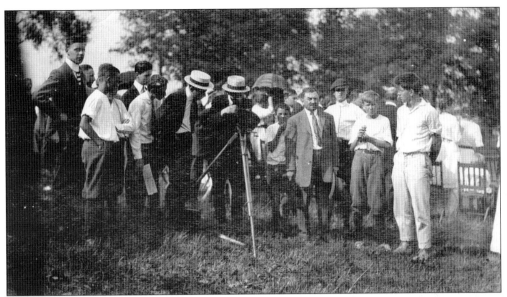

The "movie man" films the action at Lemmermann Park in 1915.

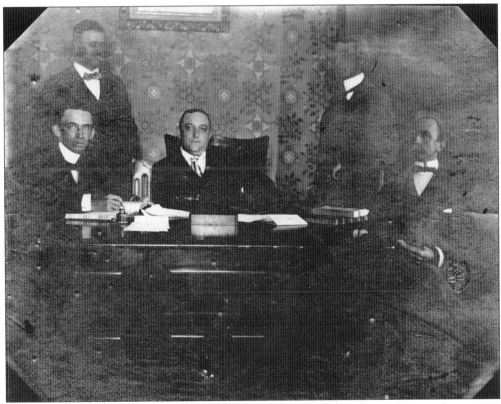

The Hasbrouck Heights Field Club Board of Governors poses for a photograph in 1899. Seated from left to right are Milnor Dominick, L. D. Hester, and Oscar Bedford. Standing are Mr. Cowells (left) and George Sternberg.

This is an interior shot of the men's lounge in the Hasbrouck Heights Field Club in 1910.

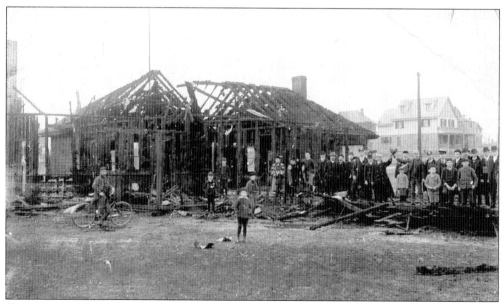

Shown is the aftermath of the Hasbrouck Heights Field Club fire. Two men hold bowling pins, perhaps salvaged from the debris.

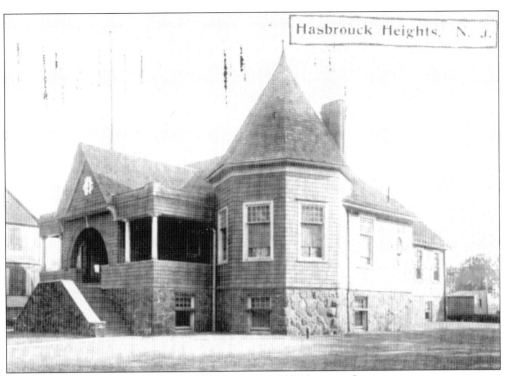

The new Hasbrouck Heights Field Club appears on a 1906 postcard.

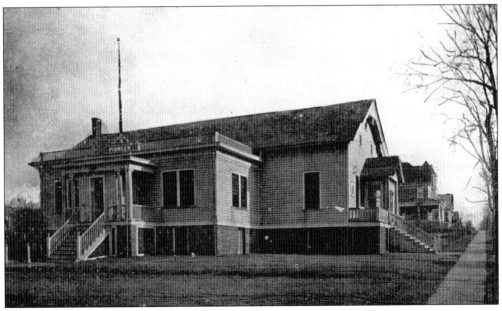

This is the Pioneer Club as it appeared in 1932.

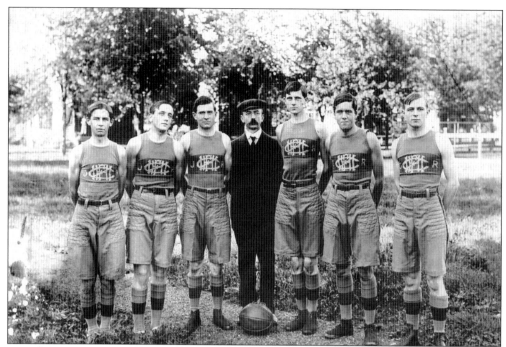

Members of the 1910–1911 Hasbrouck Heights Field Club junior basketball team pose for a photograph. From left to right are Warren Crane, Harold Bangs, Albert Martin, Oscar Bedford, George Mitchell, Horace Dunsten, and John Southwick.

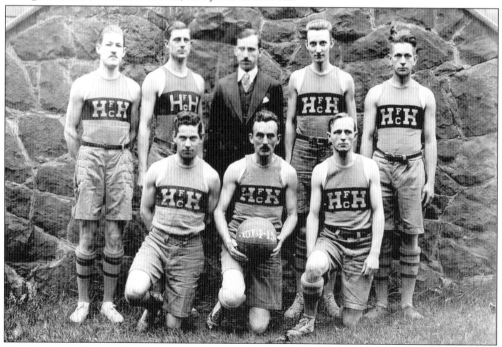

Here is the Hasbrouck Heights Field Club 1914–1915 basketball team. From left to right are (first row) William Aspin, Frank Nimmo, and John Southwick; (second row) Charles Little, George Mitchell, George Winne, Ed Cobb, and Dick LaCroix.

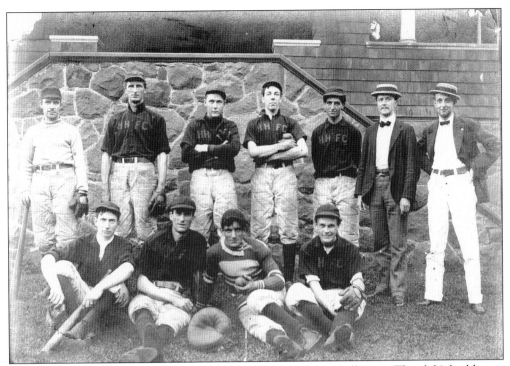

Pictured around 1920 is the Hasbrouck Heights Field Club baseball team. The club's building is behind the team.

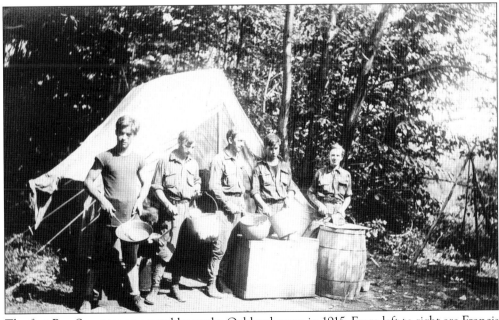

The first Boy Scout troop assembles at the Oakland camp in 1915. From left to right are Francis Scarr, Russell Peckham, scout master Bliss, Jimmy Scarr, and Paul Dietz.

This is Boy Scout Troop 68 in 1916. From left to right are (first row) Russell Peckham, Francis Scarr, and Bob Pope; (second row) Jack Blandford and Milton Peckham; (third row) George Lamb.

Shown are the members of the World War I Civil Defense Squad.

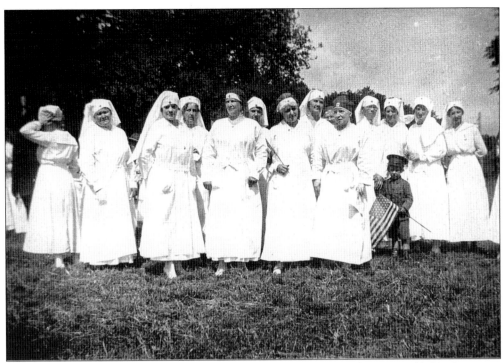

This is the Hasbrouck Heights branch of the American Red Cross during World War I.

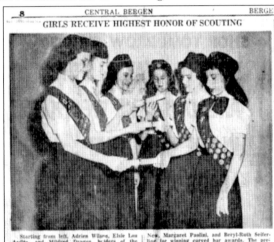

GIRLS RECEIVE HIGHEST HONOR OF SCOUTING

Starting from left, Adrien Wilson, Elsie Lou Ardito, and Mildred Dragon, holders of the curved bar, highest award in Girl Scouting, present scrolls to, continuing left to right, Carol New, Margaret Paolini, and Beryl-Ruth Seiferling for winning curved bar awards. The presentation took place last night at the Reformed Church hall in Hasbrouck Heights.

Three Get Curved Bar At Ceremony In Heights

Former Recipients Of Honor Serve As Sponsors; Parents Are Presented With Sashes

Hasbrouck Heights — The Curved Bar, highest award in Girl Scouting, was presented to Carol L. New, Margaret Ann Paolini and Beryl-Ruth Seiferling last night in the Reformed Church hall.

SCROLLS ARE READ

Former recipients of the honor, Mildred Dragon, Elsie Lou Ardito and Adrien Wilson, acted as sponsors. They read the scrolls of their candidates, listing achieve-

and Laws. The color guard was composed of Janet Kleiber, Marie Lewandowski, and Joanne Linnell. Patricia Wilkins was pianist for the program.

The pastor, the Rev. Martin A. Punt, gave the invocation and

This 1957 news article from the *Bergen Record* reports that Carol New, Margaret Paolini, and Beryl-Ruth Seiferling received the highest Girl Scouting award. They are being presented the awards by previous winners Adrien Wilson, Elsie Lou Ardito, and Mildred Dragon. (Courtesy of Elsie Ardito Sternbach.)

Here are the members of the World War II Civil Defense Squad in 1943.

Lemmermann Park is gone, and a new housing development was built around 1945. This is a view looking west on Central Avenue before Oak Grove Avenue.

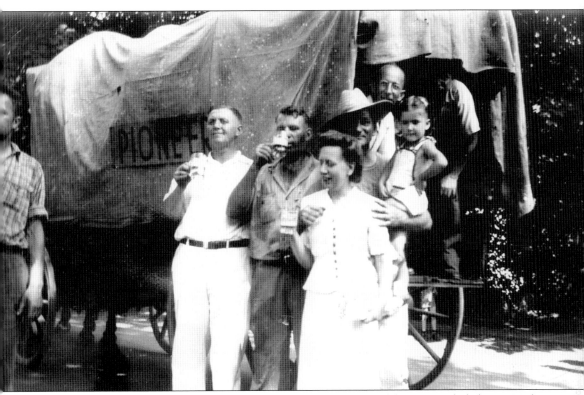

In 1944, the Pioneer Club celebrated its 50th anniversary. The celebration included a covered wagon. From left to right are three unidentified people, Louis Mentes (in hat) holding Elsie Ardito Sternbach, Marie Mentes, Bob Wolf, and unidentified. (Courtesy of Elsie Ardito Sternbach.)

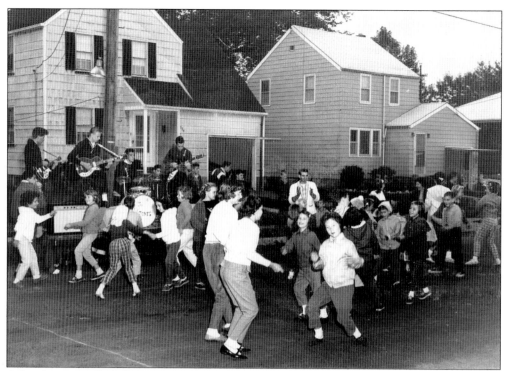

A local group called the Vitones plays the latest hits for Hasbrouck Heights children around 1958 at a block party.

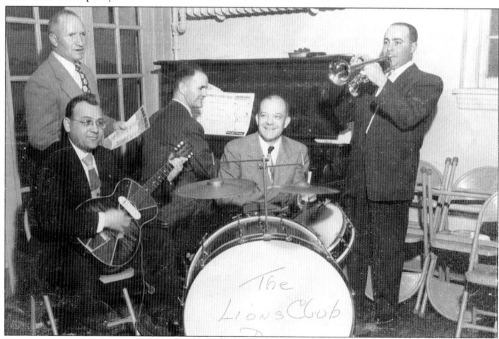

The Lion's Club Band is shown here in 1954. From left to right are Furey Pasquin of Pasquin Ford, Police Chief George Eckert, Harry Carty, William Oelkers, and Joseph Torre. (Courtesy of Thomas Mason Sr.)

Seven

HOUSES OF WORSHIP

The Methodist Church had its beginnings as Union Sunday School. The school met in the old Ravine Avenue train station. Church members later met in private homes. In the late 1870s, the Methodist Church met in the Alexander family home on Kipp Avenue. The first church building was on the southwest corner of Washington Place and Burton Avenue, but the mortgage was foreclosed, and the Reformed Church purchased it in 1887. In 1888, the membership erected a church on the south side of Jefferson, between the Boulevard and Burton Avenue. On December 15, 1905, this church was destroyed by fire. Luckily, due to a growing congregation, it had already purchased land on Division and Burton Avenues, and building commenced. The parish house, named for the Reverend Paul Callender, was constructed in the 1950s. Today, the Methodist Church also has a nursery school housed in the Callender Building.

The Episcopal Church was established in 1895 with the first service being held in the public school. In February 1896, the public school was sold to the church and land was also donated by Richard Berdan to build the Church of St. John the Divine. In 1911, the church building was moved to Terrace Avenue between Jefferson and Franklin Avenues. In 1928, construction began on the parish hall.

In 1897, Hasbrouck Heights Catholic families petitioned the Archdiocese of Newark for a church of their own. A positive response was received, and by year's end the cornerstone had been laid. Edward Anson donated the land on the western side of Kipp Avenue and the Boulevard. In 1914, part of the Dunstan Estate across the street was purchased. One evening the trolley wires were raised and the church was moved to its new site. The remaining Dunstan Estate was purchased in 1916. The Reverend Andrew Clark is credited with creating Corpus Christi Church, as it is known today. He also established Corpus Christi elementary school in 1928. In 1934, the church was enlarged and remodeled, creating the Romanesque-style church of today.

In 1893, the First Reformed Church was organized. Its first building stood on the southwest corner of Washington Place. Within a year it was enlarged, and in 1901, it was enlarged once more because of increased enrollment in their Sunday school. The new church edifice was erected on the site of the second schoolhouse. The completed enlargement and renovated church was dedicated in 1923.

In 1920, the United Lutheran Church was established, with its first service being held in the old Baptist church. As the only church in Hasbrouck Heights with a building at the time it was established, Holy Trinity Church expanded by razing the building and constructing a new one because of a growing parish. In 1963, a new church and parsonage, which included meeting rooms and a kitchen, were built.

The Bible Baptist Church has a long history in Hasbrouck Heights and Wood-Ridge. The church remained in Wood-Ridge until 1957, when the congregation purchased part of the Wisse farm on Passaic Avenue and erected a building. It was enlarged and remodeled in the mid-1990s.

Meeting throughout the 1930s, the Jewish Community Center of Hasbrouck Heights, Wood-Ridge, and Lodi was a social and awareness organization that met at a house on Cleveland Avenue. Classes and services were held in various homes, the old municipal building, and other churches. Land was purchased in the early 1950s on Harrison Avenue and the Boulevard for a center, but it became known that a building on Paterson Avenue and the Boulevard was for sale. The first service in the center was held in 1954. The Jewish center moved out in 1974, and the Board of Education later purchased the building for its offices.

The Community United Church of Christ is located on the Boulevard and Charlton Avenue. It was a denomination formed from a merger of Congregational Christian, Evangelical, and Reformed Churches.

This house was once home to the first public school and later the Episcopal Church. It is located on Jefferson Avenue.

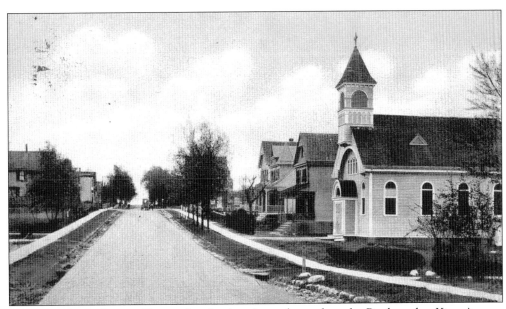

This view shows Corpus Christi church when it was located on the Boulevard at Kipp Avenue before it was moved across the street to its present home.

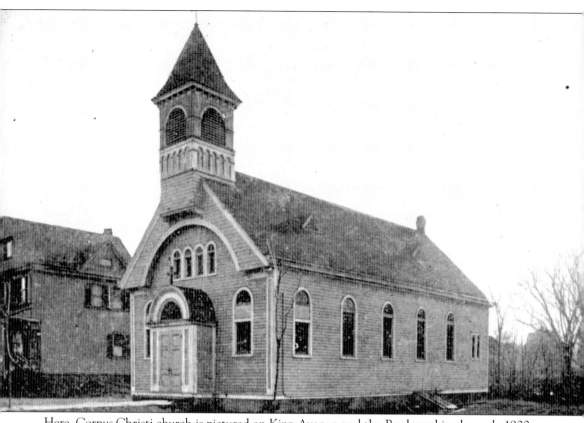

Here, Corpus Christi church is pictured on Kipp Avenue and the Boulevard in the early 1900s.

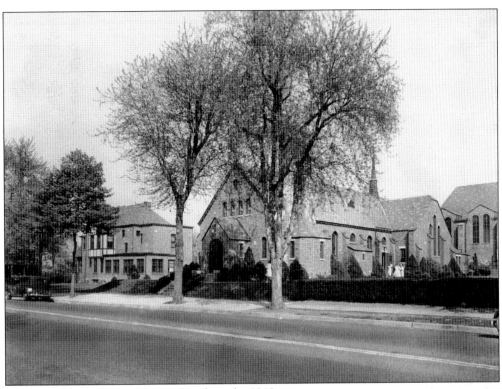

This view shows Corpus Christi church in the 1940s.

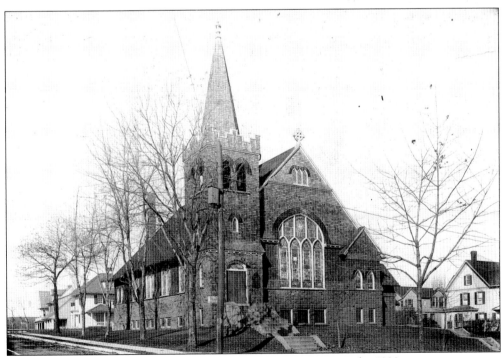

The Methodist church stands on Division and Burton Avenues in the 1920s.

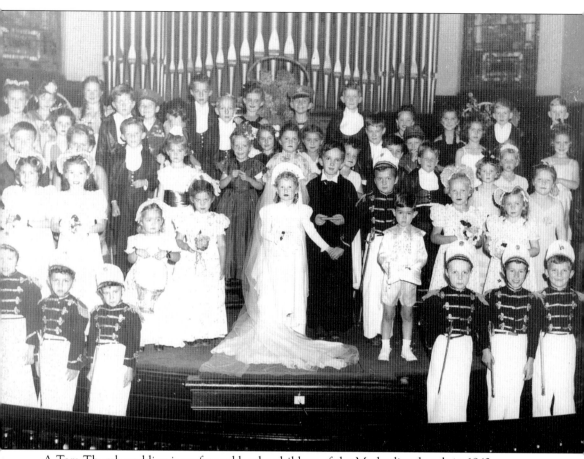

A Tom Thumb wedding is performed by the children of the Methodist church in 1943.

Shown is the 1975 Methodist Church nursery school. The author is in the second row, third from the left. (Author's collection.)

St. John's Rectory is shown in the 1930s. It was later demolished.

This is a 1908 postcard of the Episcopal church. The greeting on the back states how lucky the writer is to be visiting "the country."

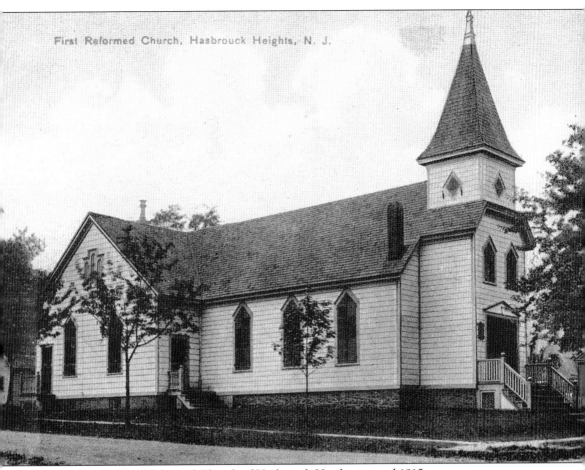

First Reformed Church, Hasbrouck Heights, N. J.

Pictured is the First Reformed Church of Hasbrouck Heights around 1915.

The First Reformed Church of Hasbrouck Heights congregation poses for a photograph in 1915. From left to right are Julian Goodrich, Harold Pope, A. K. Goodrich, Francis Scarr, William Capen, Roy Branen, Randall Overocker, Gus Ulrich, James Scarr Jr., Clifford Pope, unidentified, Oscar Steidel, Bessie Curry, Raymond Ulrich, unidentified, Ed Cobb, Edna Ulrich, Bob Martin, unidentified, Annie Ashworth, unidentified, Florence Van Biemen, unidentified, Ford Swick, unidentified, Evelyn Williams, Maureen Millicent, and Clementine Steidel.

Eight

TETERBORO AIRPORT

In 1917, Walter Teter sold hundreds of acres of land to the Witteman-Lewis Aircraft Company. The company built a factory to convert old biplanes into mail service planes. The first plane landed at Teterboro Airport in 1920. Aircraft designer Anthony Fokker purchased the plant. Fokker airplanes were used by some of the most famous aviators of the day, including Adm. Richard Byrd and Amelia Earhart. Fokker also had a business partnership with Elliott Roosevelt, son of Franklin and Eleanor Roosevelt.

In the late 1930s, Teterboro Airport came under the direction of the Bendix Corporation. Later, in 1970, Pan American Airways took over control and invested millions of dollars. The air traffic doubled. Today, the airport is under the control of the Port Authority of New York and New Jersey and is one of the busiest in the nation. Unfortunately, four accidents have occurred in recent years. In December 1999, a private airplane crashed between Central Avenue and Washington Place.

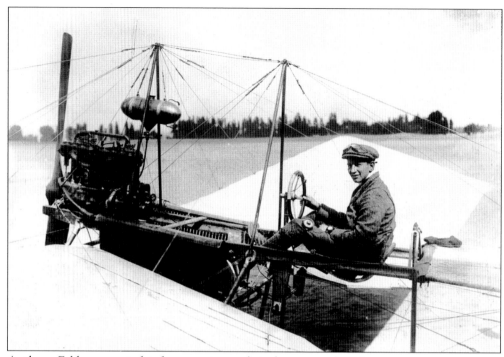

Anthony Fokker poses in his first experimental airplane around 1915.

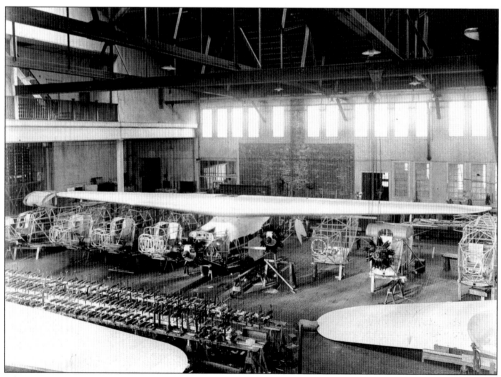

This c. 1920 view shows the interior of the Fokker plant, which at that time was part of Hasbrouck Heights, now Teterboro. Note the full plywood wings on the F-1 steel fuselage.

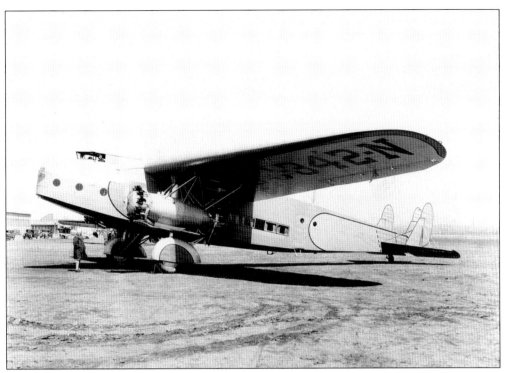

This Fokker F-32 was built in Teterboro on April 5, 1930.

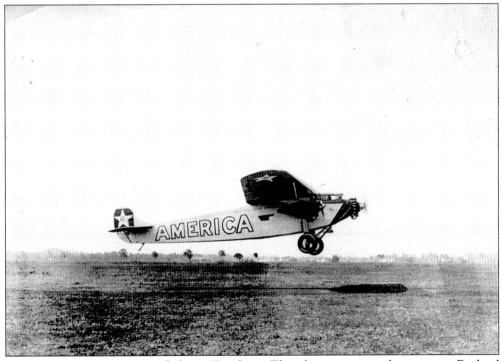

The *America* is given a test flight at Teterboro. The plane was to make a trip to England around 1925.

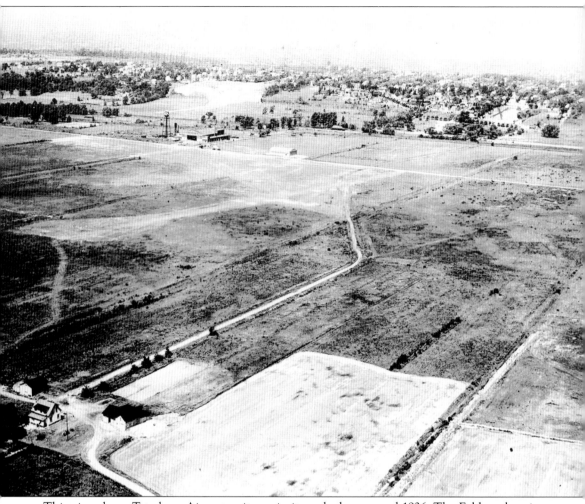

This view shows Teterboro Airport as it was in its early days around 1926. The Fokker plant is near the checkered water tower at the top left center. Hasbrouck Heights sits up on the hill.

Eddie Rickenbacker (standing, far left, in the boater hat) attends a press conference at Teterboro Airport for the new F-32 in the early 1930s. (Photograph by Henry Miller, News Picture Service.)

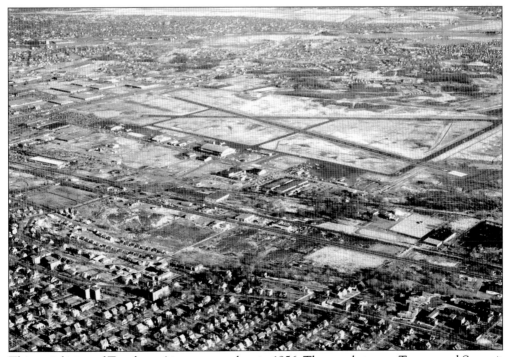

This aerial view of Teterboro Airport was taken in 1956. The area between Terrace and Summit Avenues is in the lower center. Note how sparsely Route 17 was developed. (Courtesy of Port Authority of New York and New Jersey.)

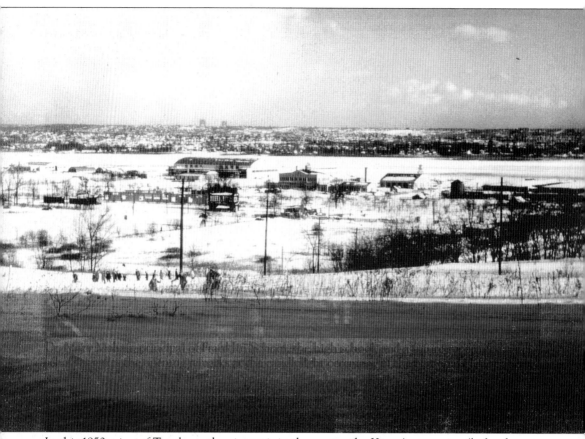

In this 1950s view of Teterboro, the airport is in the center, the Kipp Avenue area (before homes were built on the hill) is in the foreground, and the George Washington Bridge is in the distance.

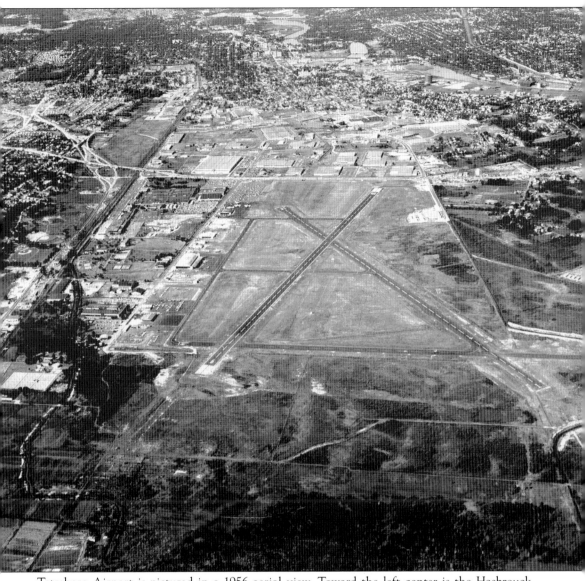

Teterboro Airport is pictured in a 1956 aerial view. Toward the left center is the Hasbrouck Heights Athletic Field.

A Weekly Digest Of Your Home Town News

The Observer

The Home Newspaper For Bendix and Hasbrouck Heights

OL. XV—No. 51 Hasbrouck Heights, N. J., Friday, March 31 1939 Price Five Cents; $1.50 Per Yea

Capt. Wilson Predicts Big Future for Airpor

chool Body Hires Kepsel As Attorney

Dr. Joseph B. Basralian was re-pointed school physician for the ar beginning July 1, 1939, by e Board of Education Monday ght, at a yearly salary of $500. so re-appointed were school rse Mrs. Ruth Hall Ponte at a lary of $950, and Ralph Farrier attendance officer at a salary $100. The appointments were commended by educational chair- in Turner C. Blaine.

The Board, later in the evening, eated a new post by appointing corder Julius Kepsel as its at- rney for the period of a year. retofore local Boards of Educa- n have engaged attorneys as the ed arose. Recorder Kepsel acted the Board in the recent special ayground referendum.

That another school year will on be over was evidenced in a solution appropriating $145 for mmencement programs, speak- diplomas and other incidentals

400 People at Quilt Pageant Of the P.-T.A.

Four hundred Hasbrouck Heights women crowded the Euclid School auditorium Friday afternoon to witness a colorful and unusual program, "The Romance of the Quilts," by members of the Euclid School Parent - Teachers' Associa- tion, featuring Mrs. William W. Harris, narrator, a display of about fifty quilts, some dating back to 1870, and a procession of thirteen ladies dressed in wedding gowns from 1850 to 1939.

Mrs. Harris, who is American Home chairman of the Sixth Dis- trict of the Woman's Club, and seeking State chairmanship, has made a thorough study concern- ing the history of quilting and has entertained many clubs in the state on the subject. She opened the program, and as "grandma" traced the making of quilts to medieval times.

Quilting came into importance the speaker said, with the neces- sity for warm bed covering, for the Puritans had only one stove in their homes, and that in the kit- chen where most of the work was

Luncheon to Inaugurate Air Course

Flight training for the first 20,- 000 student pilots who will become part of the personnel for the en- larged federal aeronautics program will be underway throughout the nation on Tuesday, April 4, when 27 undergraduates of New York University begin their practical study at Bendix Field, Bendix, N. J.

Marking the occasion, according to announcement today from Vin- cent Bendix, nationally known aeronautical leader, Federal and New Jersey state aviation officials and prominent personalities in the industry will be guests at a lunch- eon at the Bendix Aviation Coun- try Club on the day the N. Y. U. students make their initial train- ing hops.

Thirteen colleges and universi- ties in various parts of the coun- try will first train 330 pilots in a test of a widespread teaching plan, and if the results are accepted by

Rabid Dog Is Killed After Biting Youth

A rabid stray dog which had roamed Hasbrouck Heights since last Thursday was shot to death by Patrolman Frank Webb Tues- day afternoon after it had bitten a child and two other dogs. It is not known whether any other dogs were bitten.

After the dog had been killed its head was sent to Bergen Pines for analysis, and authorities there re- ported Wednesday morning that the canine had rabies. Precautions were immediately taken to prevent the child, John Busgans, 12, of 103 Henry Street, from contracting the disease.

He was bitten in the left leg Tuesday afternoon at the Boule- vard and Division Avenue and was treated by Dr. Thomas Walsh.

Earlier in the day the dog had attacked a dog owned by Mrs. Charles Gernert, while she had her dog on a leash in front of her home at 291 Terrace Avenue. Last Thursday the same dog had bitten a dog owned by Lawrence Ger- quest, of Division Avenue, his dog being on the front porch of his home

Air Directo Sees Height In Key Spo

"You have the finest opportun for the best miscellaneous air b in the world here," Captain Robb Wilson, New Jersey St Director of Aviation and techni adviser to the U. S. Bureau of Commerce, told members of Hasbrouck Heights Lions Club guests at the Old Homestead F taurant Tuesday night.

His statement came after a s ring address on aviation in wh ade air travel would be the "s est, cheapest and fastest" me of transportation, and in which lauded the Bendix Airport as of the potentially finest in country.

"You in Hasbrouck Heights in a significant spot," Captain V son said. "You can give a char ter to your community which have a far reaching effect on y sons and daughters. You are a position to hold the world by

The headlines of the March 31, 1939, *Observer* predict a big future for Bendix Airport (later Teterboro Airport).

Nine

FAMOUS RESIDENTS

Hasbrouck Heights has been home to numerous famous people because of the town's proximity to New York City and a local airport. The more recent well-known residents are best remembered, but in the early days of Hasbrouck Heights prominent residents abounded too.

In the 1890s and early 1900s William Martin, one-time president of the Building and Loan Association, was the Prohibition party's candidate for vice president. He may be the only resident to have run for this level of political office. Henry Kipp was born in 1846 and moved to Hasbrouck Heights as a young man. He purchased a farm on Polifly Road (Terrace Avenue), residing here until his death in 1898. He had been owner of the *Bergen County Herald* newspaper located in Rutherford. In addition to holding many local elected offices, he also served as a Bergen County freeholder.

John Van Bussum was a New Jersey state assemblyman from 1881 to 1886. Another gentleman elected to the New Jersey legislature was John Graves, but he died shortly after being elected to that office. Carl Lester was the Bergen County surrogate in 1902. Ralph Chandless Sr. had been a New Jersey state assemblyman and state senator. Chandless also served as the assembly speaker. Alfred Kiefer also served in the New Jersey Senate between 1966 and 1968.

In more recent history, Robert Burns served as an assemblyman for two terms, and in the 1990s, Rose Heck served as the first woman from Hasbrouck Heights to be elected to the position of mayor and then assemblywoman—quite an accomplishment. Although retired from public office, Heck continues to be an advocate for various issues related to Hasbrouck Heights.

Brent Balchen piloted for Adm. Richard Byrd during his transatlantic flight in 1927, and his first flight across the South Pole in 1929.

Resident John Thomson designed, built, and flew gliders and airplanes. He performed in air races and was a president of the Professional Air Race Pilots Association and a pilot for Trans World Airlines for over 30 years. His career in aviation led to his induction into the New Jersey Aviation Hall of Fame. The Thomson family lived in Hasbrouck Heights for more than 50 years. Thomson's father was a principal in the Hasbrouck Heights School District.

Another famous aviator was Col. Clarence Chamberlain. This Washington Place resident learned to fly at Teterboro Airport and was cheered by throngs of people when he returned home from his trans-Atlantic flight to Germany in 1927.

Former New York Giants Football coach Bill Parcells lived in Hasbrouck Heights for a time. His father and mother, Charles Parcells and Ida Naclerio Parcells, settled here, as it was convenient for Charles's position as an FBI agent. As a youngster, Parcells played ball in the vacant lot across from his home.

Hasbrouck Heights has also produced character actors such as Adam Mucci and Tracy Spindler, who have appeared in the *Law and Order* television series. The list of Hasbrouck Heights residents goes on. There have been Broadway actors, musicians, and authors residing in town. Unfortunately, there is not enough room to include them all in this book. Space is limited, but their contributions are important and have made the community extremely proud.

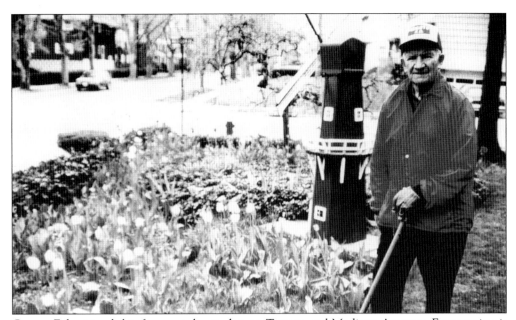

George Eckert tends his famous tulip garden on Terrace and Madison Avenues. Every spring it was a ritual to go and see all the wonderful colors. The house was torn down to make way for two new ones in the early 1980s.

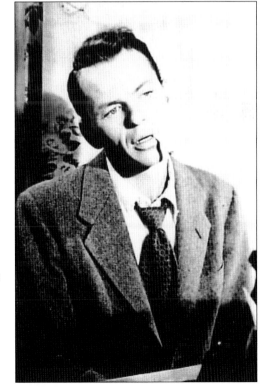

Of course one of the most popular entertainers to live in Hasbrouck Heights was Frank Sinatra. Sinatra lived on Lawrence Avenue in the 1940s with his first wife, Nancy. *Life Magazine* did an entire spread on Sinatra while he lived in Hasbrouck Heights. However, Sinatra's residency was short-lived, as he soon went on to become a popular movie actor and continue his singing career.

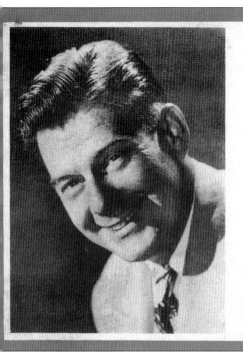

Thanks ever so much for your very nice letter... it's good to hear from folks like you... it makes this job a pleasure!

Best wishes,

Arthur Godfrey

Arthur Godfrey was a popular radio and television personality in the 1950s and 1960s. He moved here as a youngster and attended the local schools until he quit after a disagreement with the high school principal. Godfrey's mother was the organist at the town's movie house, the Strand Theater, nicknamed "the monkey house." After the disagreement, Godfrey joined the navy and briefly returned here after duty, but soon moved to California. Godfrey, who was also a pilot, often flew in and out of Teterboro Airport. Once, when not given preferential treatment to land, he buzzed the control tower. His pilot's license was suspended for a time. Godfrey even wrote a song about the event. Shown is a preprinted thank-you note from Arthur Godfrey that he mailed out in the late 1940s to fans.

His Needles to Serve Abroad

Surgical Inventor Busy at 83

Also Designer of 'Ace' Bandage

Newark Evening News
New Jersey

By ELIZABETH McFADDEN
Staff Correspondent.

RUTHERFORD — An 83-year-old bon vivant, a prime toolmaker for the medical profession, goes to work here each day this summer with special zest.

A needle he developed for "painless" childbirth is being distributed to 60 Baptist missionary infirmaries throughout Africa and Asia.

The inventor is Oscar O. R. Schwidetzky, research director of Becton, Dickinson & Co. here, and the needle—for continuous caudal anesthesia, standard equipment in countless births—was an answer to a doctor's plea.

The doctor, Robert A. Hingson of Cleveland, wanted a strong but pliable needle for the purpose. He got it from the doughty inventor some years ago. And, just last month, the Mid-westerner, an ardent Baptist, received 700 pounds of equipment, including 60 complete "painless" childbirth kits, from his inventor-friend. The physician will distribute them on an African and Far East tour this summer.

Can Afford It

"We've made plenty of money and can afford to do it," says Schwidetzky.

Little known outside the medical world, the inventor is widely recognized in that realm. He brought the "ace" bandage of stretchable cotton, boon of athletes, into American medicine. It bound hundreds of leg and arm wounds in World War I and made a comeback in World War II in the pressure treatment of burns.

Right now it's a popular piece of equipment with youngsters in Ramsey, Schwidetzky's home town. The trim,

DEMONSTRATION—Lively, 83-year-old Oscar O. R. Schwidetzky of Ramsey shows off applying Ace bandage to ankle of Miss Carolyn Jaskiewicz Hasbrouck Heights.

160-pound instrument maker likes to walk and he likes to talk to kids. One of the things he tells them is how ace bandages can protect a fellow from injury on the ball field.

The result: "Those Ramsey kids have more ace bandages than a hospital."

Has Received Honors

Schwidetzky himself has a raft of honors. Fairleigh Dickinson University gave him an honorary degree of doctor of laws five years ago for his "lifetime of service in alleviating pain and suffer-

ing." Johns Hopkins Hospital dedicated a room on the delivery floor to him, and the International Anesthesia Research Society, in a rare action, voted him an honorary membership.

Schwidetzky feels, looks and acts as though life were good to him. He loses at gin rummy pretty regularly and his golf game is "questionable." In the kitchen, however, by his own admission, he turns out a "mighty nice" sauerbraten. Not too many years ago he won second prize

test. His entry: red cabbage and potato dumplings.

To counteract the effects of his culinary art, Schwidetzky leans on his training in the German army. He now does precisely eight minutes of exercise each morning in his home at 31 Lakeside Dr., Ramsey. This discipline features six pushups, keeping his biceps as hard as the steel in the countless hypodermic needles he has developed—and tested on his own sturdy legs.

Perhaps one of the least known residents, but very important to contemporary daily life, was the director of research at Becton, Dickinson and Company, Oscar Schwidetzky. Schwidetzky invented the Ace bandage, the caudal syringe for painless childbirth, and the Greely unit, which was a pain-relieving device carried by soldiers. Although not a medical doctor, Schwidetzky was inducted into the Association of Medical Directors in 1933. Above is a news article from 1958 showing Oscar Schwidetzky applying an Ace bandage to Hasbrouck Heights resident Carolyn Jaskiewicz. The news article was written after he moved out of Hasbrouck Heights.

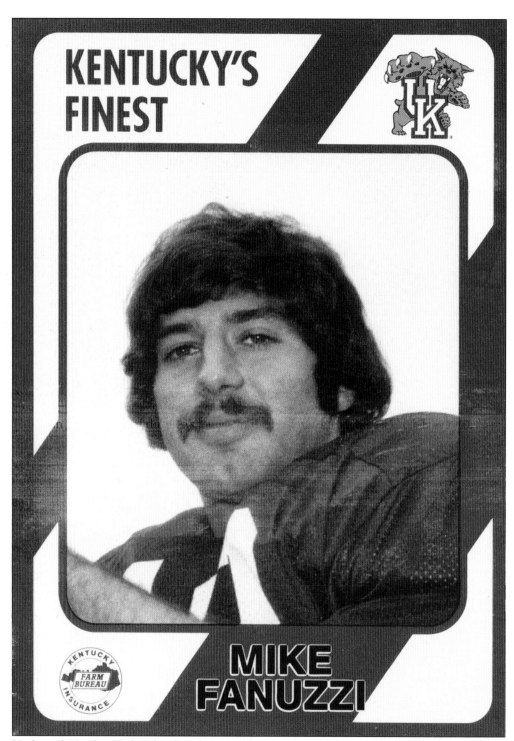

KENTUCKY'S FINEST

MIKE
FANUZZI

Hasbrouck Heights High School graduate and a phenomenal athlete Mike Fanuzzi became a star quarterback at the University of Kentucky. He is pictured in 1974.

Raphaeline Di Janni was the choir director at
Corpus Christi School. This portrait of her
hangs in the Corpus Christi School Library.
(Photograph by Steven Turi.)

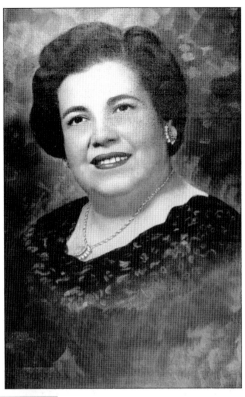

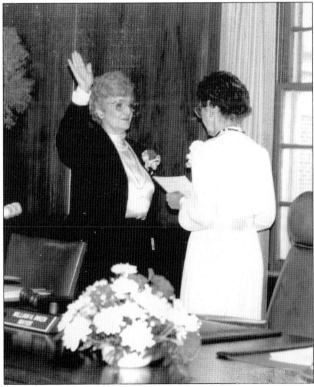

The first woman mayor, Rose
Marie Cicolella Heck, is
sworn in by the first woman
borough administrator, Louise
Davenport, on January 1,
1990. Davenport later became
borough historian.

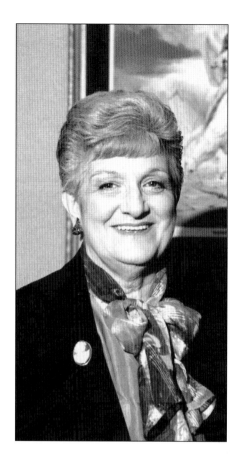

Rose Marie Cicolella Heck, the first woman mayor in Hasbrouck Heights, went on to become an assemblywoman from the 38th legislative district.

The first bill signing in Hasbrouck Heights took place on August 18, 1999, in the Hasbrouck Heights Free Public Library. Pictured with Gov. Christine Todd Whitman are Rose Heck, assemblywoman and former mayor, and Michele Reutty, library director.

Hasbrouck Heights football standout Scott Slutzker is pictured as a member of the Iowa Hawkeyes team. He later went on to play for the New Orleans Saints.

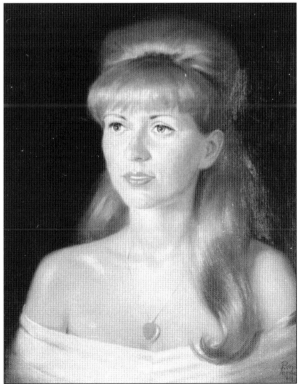

Renowned portrait artist Roy Gates Perham lived in Hasbrouck Heights his entire life. He painted numerous famous people such as senator and presidential candidate Edmund Muskie of Maine. His portraits, which commanded a tremendous price, grace the walls of many local buildings and homes. Shown is a portrait of Phyllis Irwin Fass painted by Perham around 1967.

The 1990s brought another Hasbrouck Heights resident to the screen. Jason Biggs first appeared in the soap opera *As the World Turns*. He later moved on to the big screen with movies such as *American Pie*. Biggs has also appeared on stage in *Conversations with My Father* and the revival of *The Graduate* with Kathleen Turner.